FOR LOVE AND MONEY

Portraits of Wisconsin Family Businesses

CARL COREY

WISCONSIN HISTORICAL SOCIETY PRESS

Published by the Wisconsin Historical Society Press
Publishers since 1855

Photographs © 2014 by Carl Corey
Foreword text on pages 1–3 © 2014 by Michael Perry
Remaining text © 2014 by the State Historical Society of Wisconsin

wisconsin**history**.org

Printed in Wisconsin, USA
Designed by Percolator

18 17 16 15 14 1 2 3 4 5

Library of Congress Cataloging-in-Publication Data
Corey, Carl.
 For love and money : portraits of Wisconsin family businesses / Carl Corey.
 pages cm
 ISBN 978-0-87020-646-7 (hardcover : alk. paper) — ISBN 978-0-87020-647-4 (ebook)
1. Family-owned business enterprises—Wisconsin—Pictorial works.
2. Wisconsin—Commerce—History—Pictorial works.
3. Architectural photography—Wisconsin. I. Title.
 HF3161.W6C67 2014
 338.7—dc23
 2013035020

For Kay Corey,
my wife and partner for over three decades

ACKNOWLEDGMENTS

ACKNOWLEDGMENTS ARE STRANGE THINGS. There are always so many folks involved in one's life that it is almost impossible to credit them for a singular result. Those of you who are my friends and family know who you are. I am the product of the relationships we have, and what I do is deeply influenced by you. For that I am most grateful.

Appreciation is due the folks at the Wisconsin Historical Society Press, not only for their continued belief in my projects but also for the stellar work they've done on my behalf. A better team I can't envision. A particular callout to my editor, Kate Thompson, for your enduring respect and wonderful suggestions. Your work may be mostly behind the scenes, but it is essential to the success of the books we have done together.

Thank you to Graeme Reid, my supporter and friend at the Museum of Wisconsin Art, for your continued support of the visual arts and all things Wisconsin. You see so well.

Thank you to Michael Perry for your wonderful insight and for sharing your ability to string words together like no one else. You are a true Wisconsin treasure.

This project would never have been if it were not for the people in these pictures. I applaud you, your families, and your businesses. I know how hard you work and how dedicated you are. I hope you all are as proud of yourselves as you deserve to be. I thank you for your gracious willingness to participate in *For Love and Money* and wish you the best of continued success in your endeavors.

ABOUT *FOR LOVE AND MONEY*

I LIKE KEEPING THINGS SIMPLE. Simple pictures, simple story, simple life. Simplicity provides clarity of vision.

The criteria for this project were simple: Wisconsin family-owned businesses in existence a minimum of fifty years. *Simple* works for these pictures, because the stories behind them are not. All are steeped in history, love, family, business, and community. Each of those threads is complex on its own; taken together they become a maze. The family businesses portrayed here have lived and evolved over a minimum of fifty years, against all the odds of survival. The owners remain loyal to their companies, their families, and themselves. They weather tough economic times and big-business competition. Here they are, ready to serve you and proud to do so. Here they are in their commitment, dedication, and perseverance. Here they are, pure and simple.

—Carl Corey, 2014

FOREWORD

by Michael Perry

HAVING MET NEITHER THE SUBJECTS nor the photographer of *For Love and Money*, I have viewed these portraits with no prior knowledge save the fact that each image represents a family-owned business that has survived for at least fifty years.

Survived.

If ever there was a singular synopsis of what it is to survive as a small family-owned business, see the shoe-seller's portrait on page 61. Take a moment to count the boxes. Understand that the boxes depart the store only one pair of feet at a time; then consider what it takes to divert those feet through your front door in the first place. Next, visualize the net profit per shoe as loose change rattling in each shoebox. Now imagine shaking the money out of box after box, cents on the dollar, time after time, until you've paid the rent, the heat, the health insurance, the grocery bill, bought your own kids' shoes . . .

"Here is the secret to successful self-employment," a man once told me. "Wake up *scared* every morning." It would be overdramatic—and insulting—to say the photographs in this book are populated by fearful eyes, but I believe I can respectfully state these are eyes leached of all entrepreneurial illusion.

LOOKING AT CARL COREY's photograph of a worn United States flag hanging above a fresh white set of home appliances, I am reminded that here in America we fetishize the concept of the individual, and—as a subcategory of the same—laud small business, a habit of approbation so inborn that we can sing it even while sailing freely past Mom and Pop and their outdated cash register and arrive at the megastore with coupons and a clear conscience, knowing the washers and dryers are cheaper there. Nowhere is individualism touted more than in advertisements, in which the much-coveted status is achieved by purchasing a lot of just the right thing, be it a slimmer phone, a sleeker car, or slimmer and sleeker themselves. Carl Corey's photos are a useful corrective in this regard, because he too is bringing us images of individualism, but rather than purchasing their individuality at retail, his subjects have laid their own tails on the line while crossing their fingers it's not a railroad track.

In popular culture, individualism and success are often portrayed with an air of insufferable exhilaration. The individualism in *For Love and Money* has a firmer set to its jaw. These are people who know what it is to be in charge of the inventory *and* the broom. See the image of the store owner with the empty shopping cart, standing in an aisle stacked floor to ceiling on either side with colorful games, crafts, and puzzles? Follow the linear perspective of the laden shelves and note the point of convergence: the man himself. In part this is Carl Corey knowing how to place his subject. But mostly this is the way it is.

Carl Corey's photos capture the pride of the small-time business owner, yes, and well-earned, but also the haunt of working small in a country that loves to praise the little guy even as it happily hands over more and more territory to the big boys, and furthermore forms human bridges to help the cummerbund bunch safely to dock when the yachts take on water. Corey's pictures present the faces of people who have learned to count on nothing. Who know what it is to work without a net, with the constant awareness that at this level there will be no bailouts beyond your own bucket, so pack your own parachute, no matter that it might be little more than a single white handkerchief waving goodbye.

In photo after photo, you see the price of going it alone.

WELL, SHOOT. In my determination to read these photographs deeply and properly honor the entrepreneurial pluck of their subjects, I fear I have failed to convey the fact that this book is a testament suitable to be read as something other than scripture for a wake. Fifty years: you do not stay in business for that long without *success*. Perhaps not jet-set success, or recession-proof success, or even ride-a-used-golf-cart-into-the-sunset success, but success nonetheless. Thus in many of these faces you see satisfaction. Not smugness, nothing that will leap boldly off the corporate brochure, just some quiet knowledge that certain virtues—hard work, perseverance, loyalty—

are yet extant despite all postmodern cynicism and irony, and despite all post-postmodern candy-floss paeans to the same in any given kitty litter commercial.

And Carl Corey is good at giving us glimpses of the humanity—and even goofiness—that give lie to the idea that survival is a nonstop grind. Consider the dark scarlet warmth of the pub shot—you think those three fellows won't flow stories for as long as you flow beer? And the café owner who rests one arm on a plastic high chair knows that what he has his arm on there is a totem to the idea that new customers are born every day. The bright blue of the butcher's gloves serve as their own happy little disruption in a photograph that is otherwise all sterility and meat. A group of men in casual businesswear sit surrounded by holy vestments, gilded crucifixes, and plaster angels, grouped around a table garnished with Jesus bleeding on a crucifix. The barkeep with rifles tagged for sale back above the whiskey, the store selling wine and shotguns—these are images that either catch your breath as unthinkable, or, if you're from around these parts, let you know you're in a familiar establishment.

Corey is also good at giving us points of extrapolation, if we will take the time. Take the time to consider, for instance, how the very posture of small business has changed when we see the man in the ballcap warmly framed in a series of lightening squares, his head tipped back at the modern angle required to study a computer monitor, when just a few decades back he would be hunched above a ledger. Or the sign with instructions on how to call the ambulance using a seven-digit number, and the fact that long after 911 has become common knowledge, removing the sign is still on the to-do list.

Happily, hardly anyone in this book is truly going it alone. Even the sole proprietor has someone behind her if she's been in business for fifty years. These are family businesses, after all. There is a lot of shoulder-to-shoulder. The phrase "we're all in this together" takes on a whole different light when we see Corey's images of a father

shoulder-to-shoulder with a son, a wife shoulder-to-shoulder with her husband, or a logger shoulder-to-shoulder with his horses. There is a patience to these photos born of people who know what it is to make something for the customer and then wait for the customer. To simply stand there with your wheels of cheese, saying, This is what we make, this is what we sell. If you want some, we have some.

Fear, hope, determination, whatever you see in Carl Corey's portraits, I would argue there is one other character strain evident throughout *For Love and Money*, and it has to do with low-key stubborn cussedness. Sometimes triumph of the human spirit is best expressed not by brassy fanfare but rather by heels dug in the ground.

Look at the logger again, his leather coat so worn to his work that it has taken on wrinkles and a posture of its own, not unlike the hide of a rhino. There is something in that coat and something in that logger's eyes that say, Yes, I know there are better ways to survive. But this is *my* way.

And furthermore: Define *better*.

INTRODUCTION

by Graeme Reid, Museum of Wisconsin Art

SIMPLY PUT, CARL COREY TAKES IMPORTANT PICTURES. Despite having required less than a second to create, within their stolid, quiet compositions they encapsulate decades, as well as factors not so readily apparent: loyalty, honor, trust, commitment, faith, and pride.

Indeed, generations from now, these pictures may be seen in two ways: as quaint last vestiges of twentieth-century American commerce, or as a pictorial pause in ongoing familial legacies. Only time and the vagaries of local, national, and global business will tell, but whatever happens, these images will remain indelible markers of an increasingly endangered entity.

Predominantly located in small communities, the businesses Corey photographs survive despite—or perhaps because of—globalization and the Internet. While disparate in focus, they are unified because they record two cherished and vital functions: making things, and providing personal service. In other words, the businesses included here are throwbacks to the centuries-old trades system of guilds, of skills and knowledge being passed down through generations. In many of the images it is reassuring to see younger family members standing proudly in their places of work. As society becomes more mobile and global, remaining in situ rather than seeking one's fortune farther afield requires both restraint and commitment.

While these are Wisconsin pictures, they are equally *American* pictures. For viewers of this book, the familiarity of a local business—maybe even one within their own family—will strike a chord, prompting reflection, appreciation, or perhaps a sense of wistful loss over what has been slowly vanishing from the fabric of American commercial life. In some ways these photographs might benefit the type of companies featured: readers will be reminded to renew their patronage of a long-standing local firm rather than go to a big-box retailer. However, choosing to patronize these businesses demands a mindset not entirely in sync with modern retail trends. Few of them have an online presence but instead rely on community involvement and physical engagement, personal relationships, and service to maintain their customer base. When you deal with these businesses, you deal with the owner, the creator of the product.

As Americans we are metaphorically programmed to strive, to move up the social and economic ladder, to pursue the American dream of having a life and possessions bigger and better than those of the previous generation. It can be argued that Corey's subjects and their businesses represent a sense of accomplishment, of having achieved what that dream represents for them: community, a physical and financial living, a sense of belonging, of providing a much needed service, of making something of quality and value. They have, to a great extent, achieved contentment even though they live in a world where their way of life is increasingly threatened, even disappearing.

Contextually Corey's photographs perpetuate a rich legacy of images of workers, starting with the Worker Photography movement of the 1920s and 1930s, which had an overt political agenda and arguably created the concept of the photo essay. Corey's work is more subtle in its political and economic commentary. His pictures are also strongly reflective of August Sander's iconic images of Germans from the same period. The passage of time has imbued Sander's images with a stark realism that anchors them to a particular time and place; Carl Corey's pictures do the same.

Corey's book *Tavern League* was lauded for its sense of place and the role that particular place plays in society. The images in *For Love and Money* pick up those same themes but push the element of time to the fore. As current and future generations come and go, these pictures will survive in the hands of the subjects, collectors, museums, and galleries. Will the businesses featured enjoy a similar longevity? Only time will tell, and we can only watch and hope, but Carl Corey has ensured that they will not be forgotten—not just by taking these images, but by ensuring that they become tangible objects though prints or book reproductions. His subjects are in many ways throwbacks to an earlier way of doing business, and they deserve to be made "real" and not remain in a modern, digital format within a memory card or hard drive. This book gives them the physical longevity they deserve.

FOR LOVE AND MONEY

**Mule Skinner Horse Logging,
Springbrook
Established 1929**

Taylor Johnson thinks of his horses, Mark
and Dan, as family members. Taylor is a
fifth-generation horse logger.

#2919

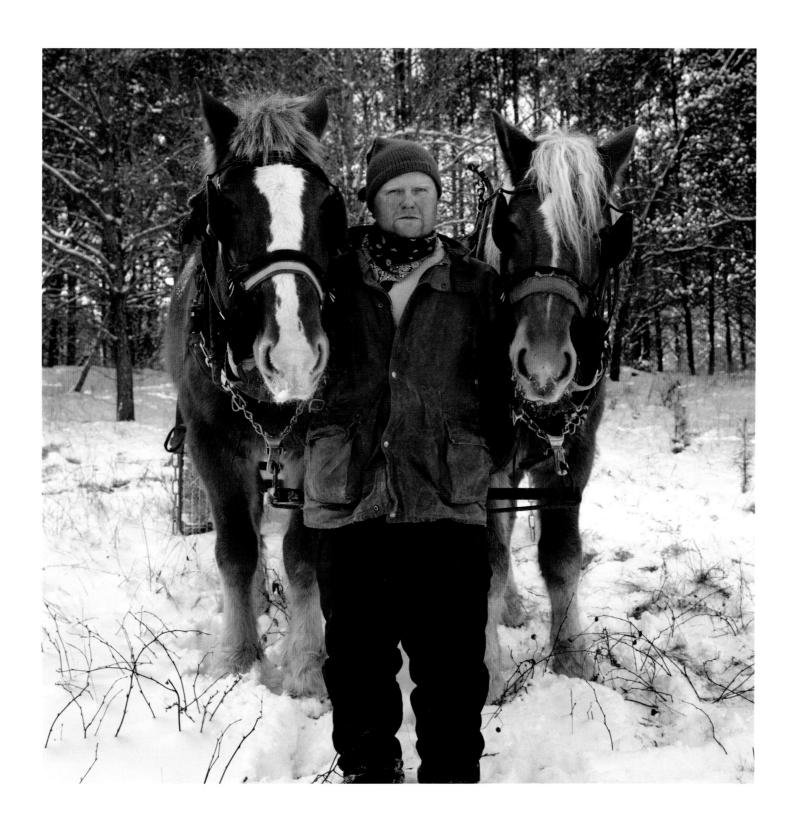

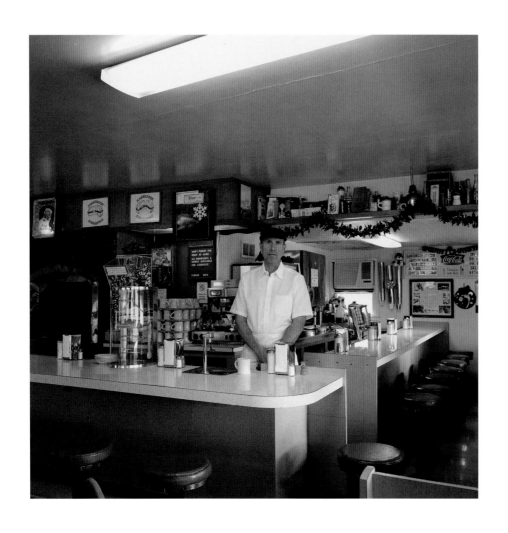

Mickey-Lu Bar-B-Q, Marinette
Established 1942

Mickey-Lu's owner Chuck Finnessy
is proud of his family's small diner,
which *USA Today* has declared
Wisconsin's best burger joint.

#3128 | #3130

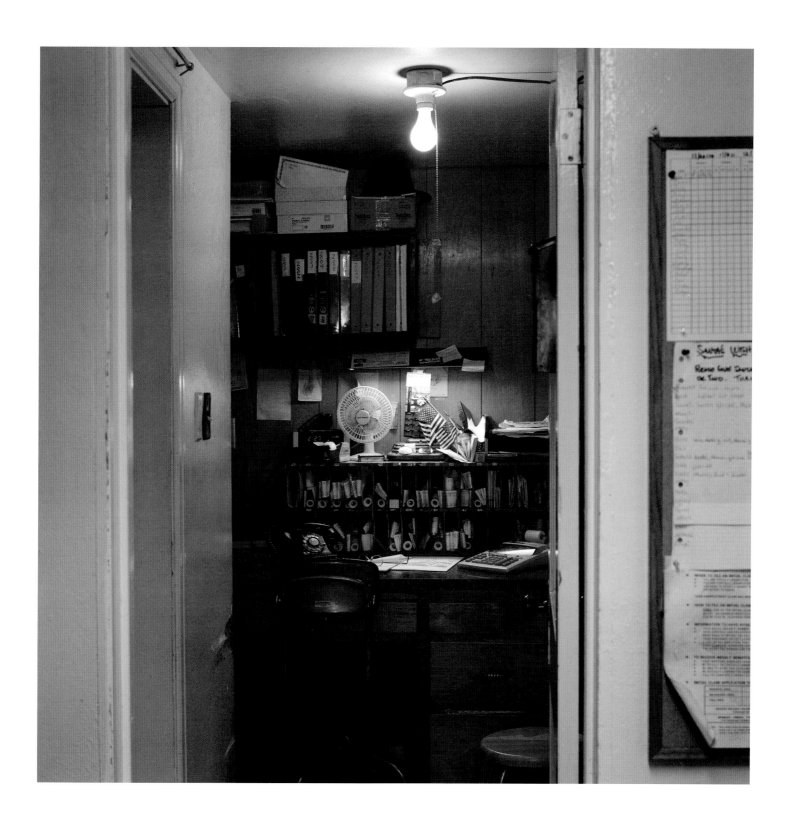

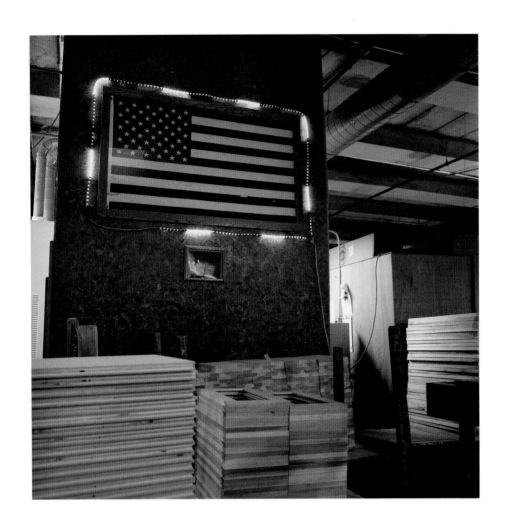

A.A. Laun Furniture, Kiel
Established 1892 as
Kiel Manufacturing Company

A group of citizens formed Kiel Manu-
facturing Company in 1892 to provide
steady employment for the people
of Kiel. At right, company president
Jonathan P. Laun sits next to a portrait
of his father, John H. Laun.

#3906 | #3922

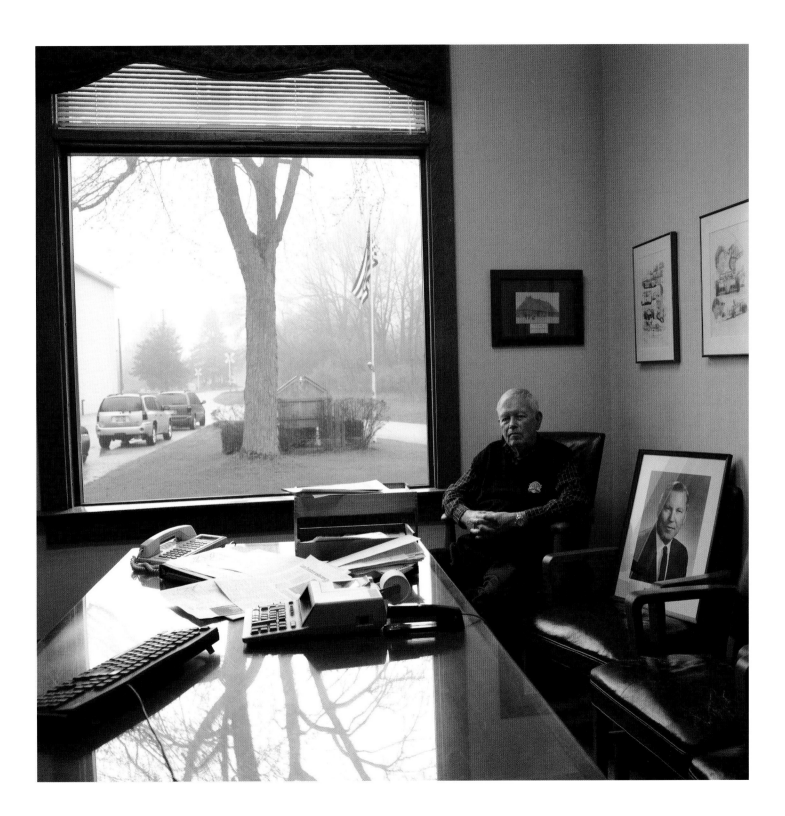

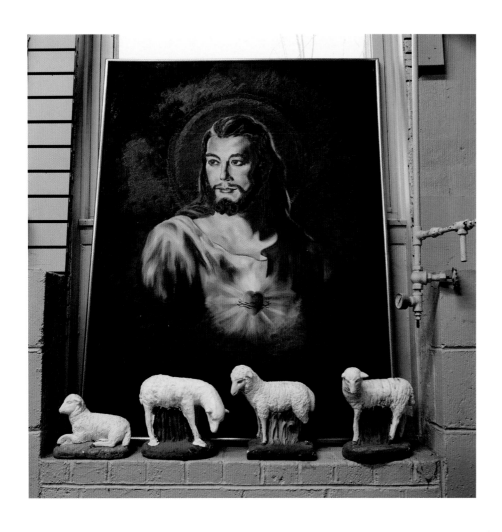

**T.H. Stemper Company, Milwaukee
Established 1911 by Thomas H. Stemper**

The Stemper brothers—from left,
John, Joe, Peter, Dan, and Jim—run the
religious goods company their grand-
father started in 1911. They're serious
about their business, but they have a
great camaraderie and sense of humor.

#3157 | #3161

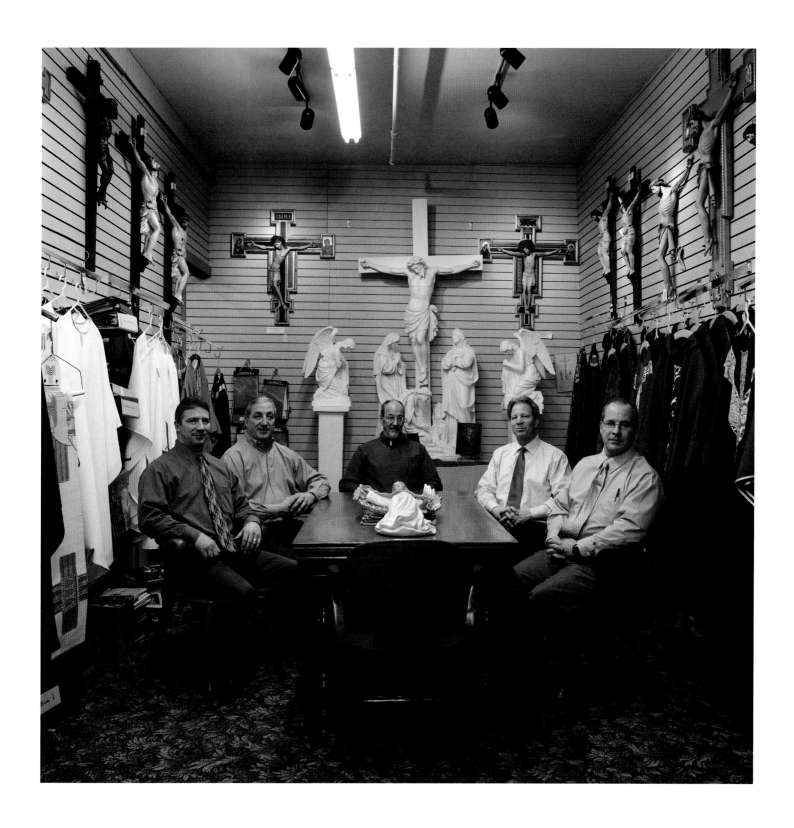

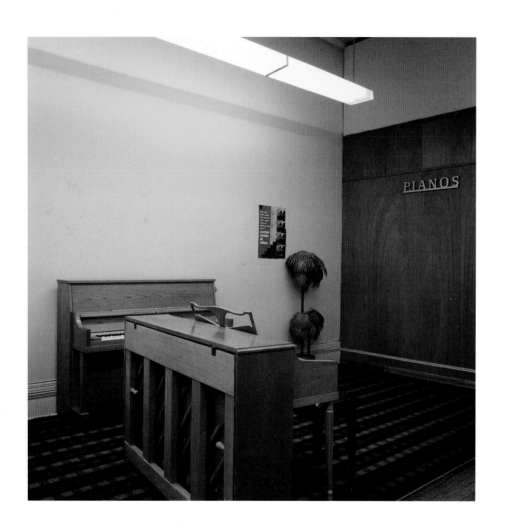

Leithold's Music, La Crosse
Established 1888 by Fred Leithold

Leithold's Music, run by siblings Paul
Leithold and Abbie Leithold-Gerzema,
repairs instruments from all over the
country. Instrument repairman John
Helm, right, showed me how to remove
a dent from a flugelhorn.

#3061 | #3062

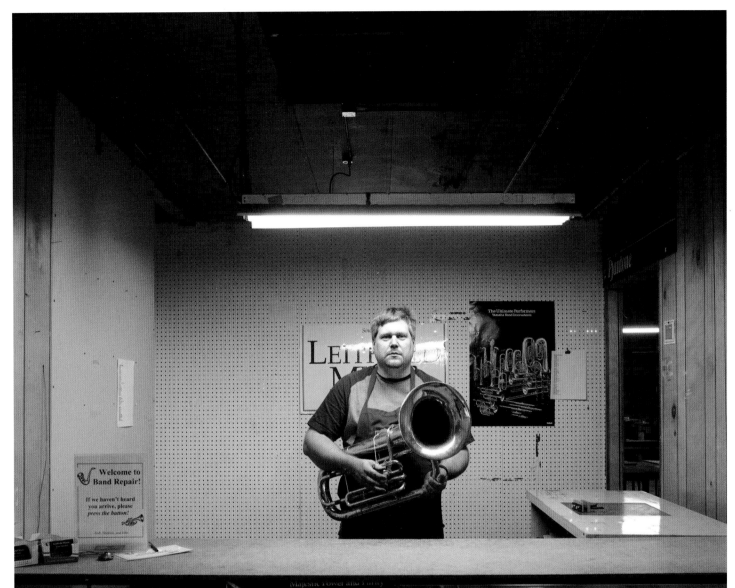

**Satin Wave Beauty and
Barber Shop, Milwaukee
Established circa 1955 by
James Flipping**

Ronnie Sherrill is proud of his Uncle Flip,
who started Satin Wave. The business is
community orientated and while I was
there was host to plenty of discourse.

#4195

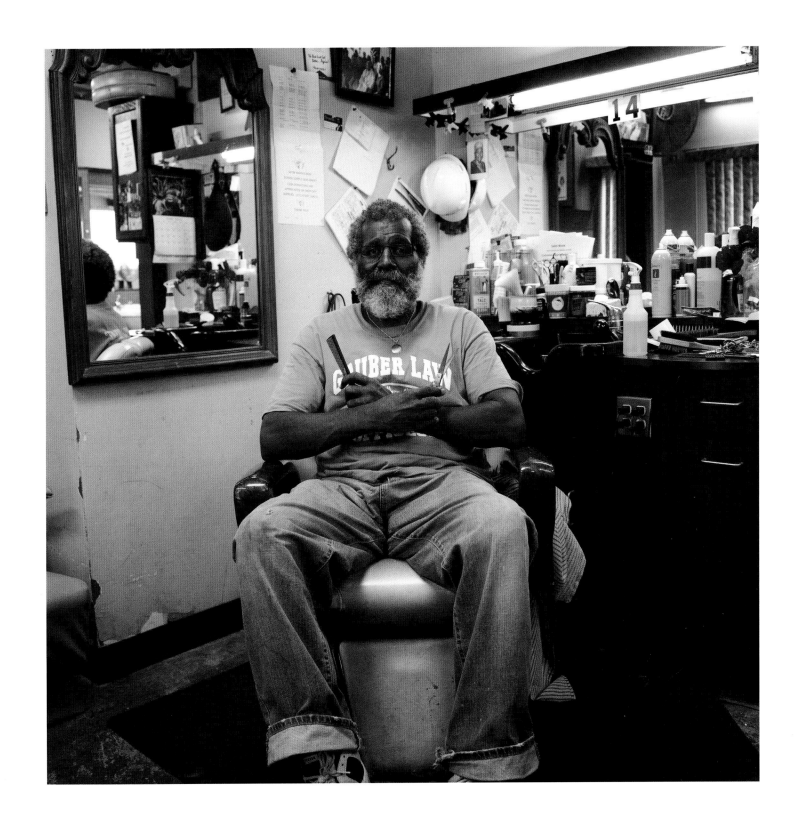

**Chanticleer Inn, Eagle River
Established 1951 by John and
Betty Alward**

Chef Gary Kreger spent thirty-six years
at the Chanticleer, earning the Wisconsin
Innkeepers' Employee of the Year award
in 2001. The inn is run today by Jake and
Sue Alward; Jake bought the place in
1972 from his parents, John and Betty,
who founded the World Championship
Snowmobile Derby on nearby Dollar Lake.

#3104

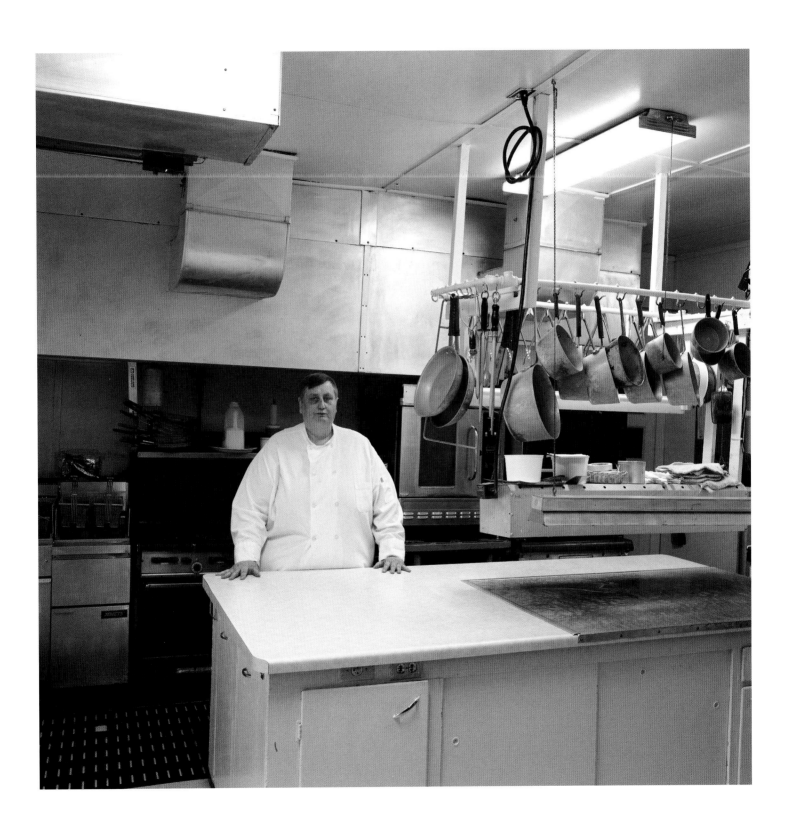

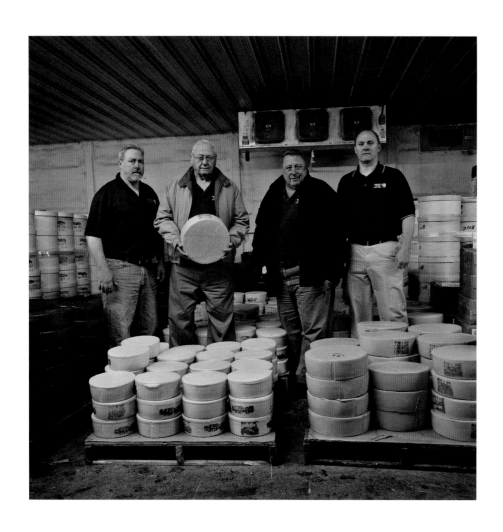

Renard's Cheese, Algoma
Established 1961 by Howard Renard

Brian, Howard, Gary, and Chris Renard
make their award-winning cheeses from
milk picked up every day from family
farms in Door and Kewaunee Counties.

#3343 | #3341

Kroner Hardware, La Crosse
Established 1868 by Adam Kroner

Walter Marx, a floor man at Kroner's, must love his job—it's the only one he's had since returning from WWII in 1947. The store is run by Bill Kroner (great-grandson of the founder), who consults often with his dad, Edgar, and uncle Jim, the majority owners of the business.

#3073

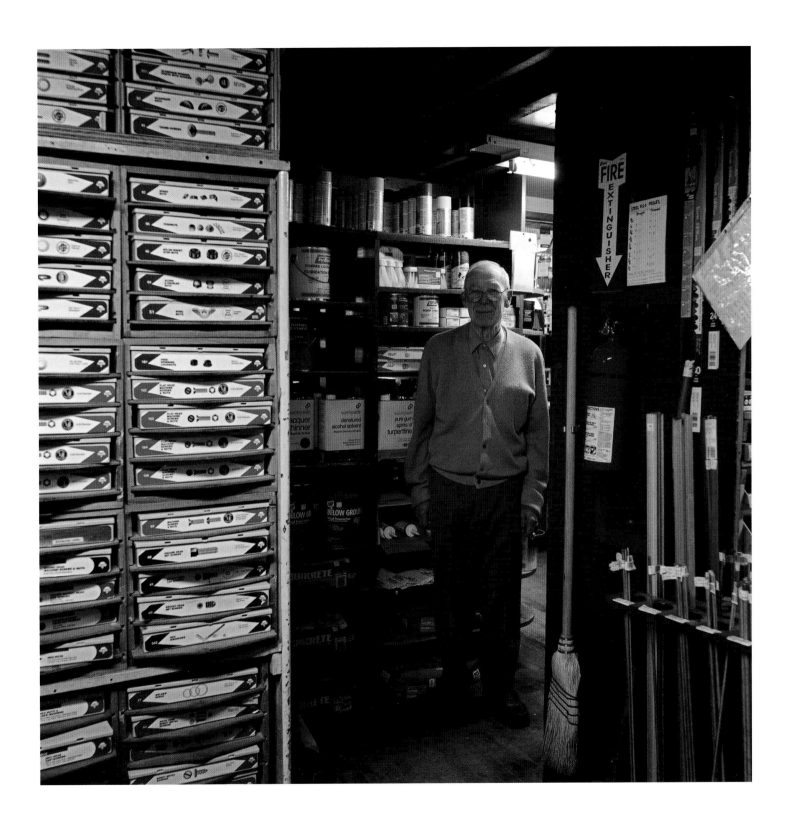

**Pete's Hamburgers, Prairie du Chien
Established 1909 by Pete Gokey**

Phyllis Gokey, here with employee Ron,
operates the burger stand started by her
father-in-law, Pete. Phyllis went home
and changed into "nice clothes" for her
picture after working all day at the grill.

#3564

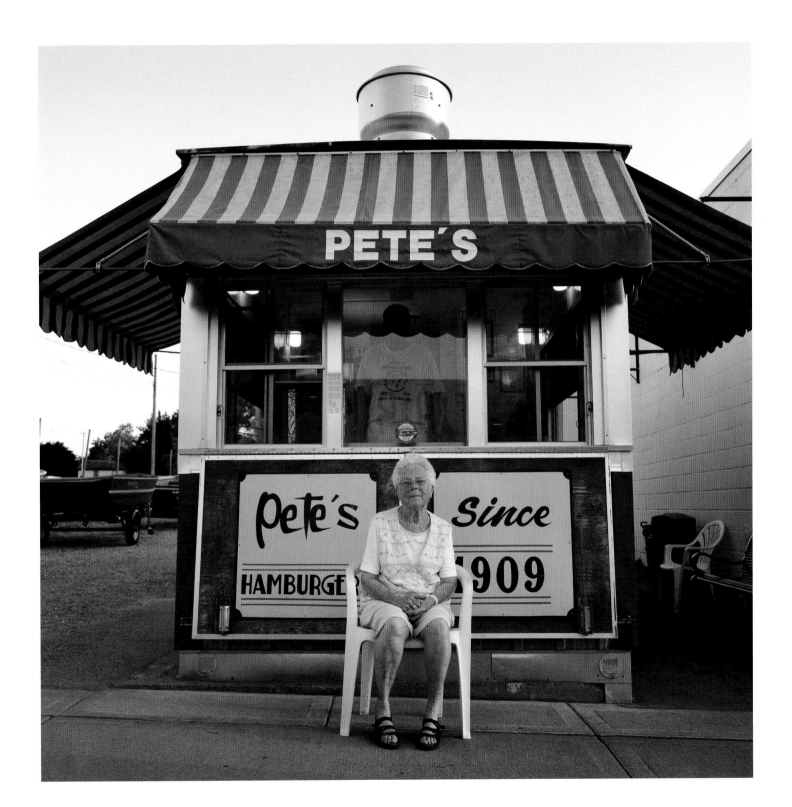

Russell Moccasin, Berlin
Established 1898 by Will Russell;
purchased 1924 by Bill Gustin

Ralph Fabricius (center) runs the
company his father-in-law, Bill Gustin,
bought in 1924. He and his staff,
including daughter Sue and son Bill,
make footwear by hand based upon
a custom mold of your feet—arguably
the finest handmade boots and shoes
made anywhere.

#3897

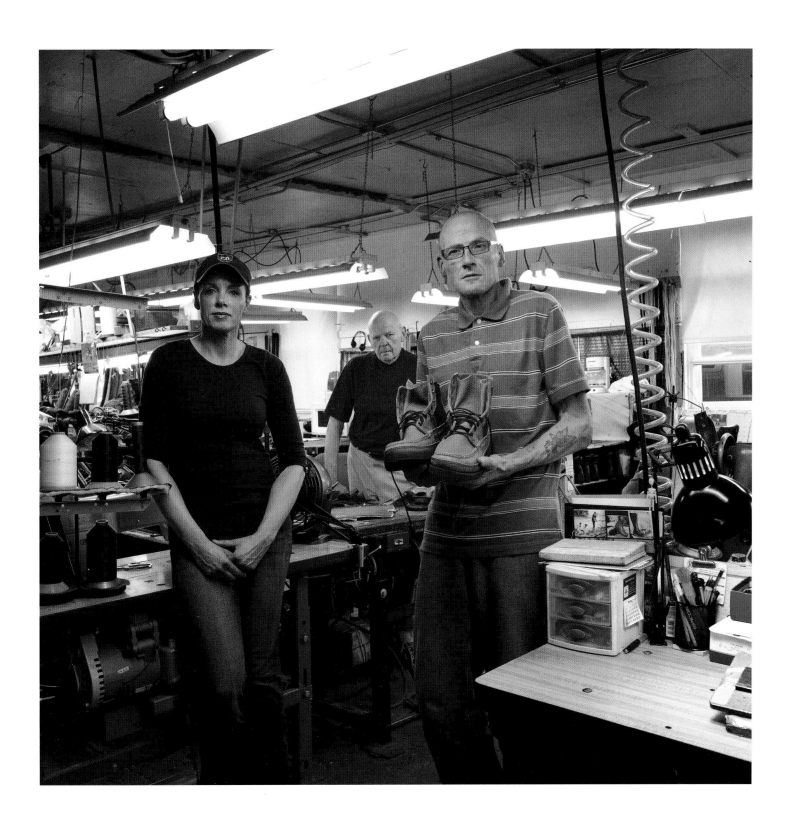

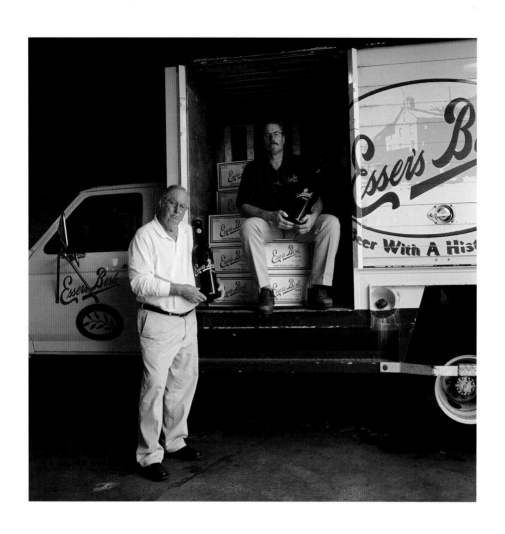

Esser's Brewery, Cross Plains
Established 1863 by George Esser

The Esser family has been in the brewing
business for 150 years. Father-and-son
team Wayne and Larry Esser make one of
the best lagers I've tasted, Esser's Best.

#3654 | #3659

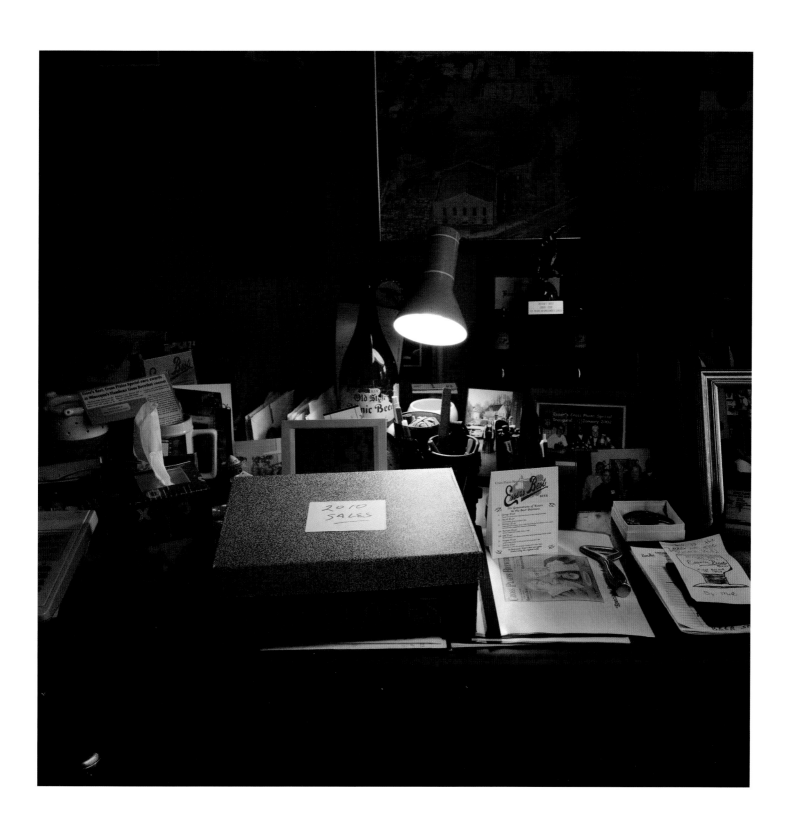

**Washington Island Ferry Line,
Washington Island
Established 1940 by Arni and
Carl Richter**

Washington Island Ferry Line started
in 1940 with two wooden ferries. Today
the company uses modern Coast
Guard–approved vessels that make up
to twenty-five round trips a day during
high season. At right, Richard Purinton
and his son Hoyt hold a photograph
of Arni Richter, Richard's father-in-law
and cofounder of the ferry line.

#3352 | #3354

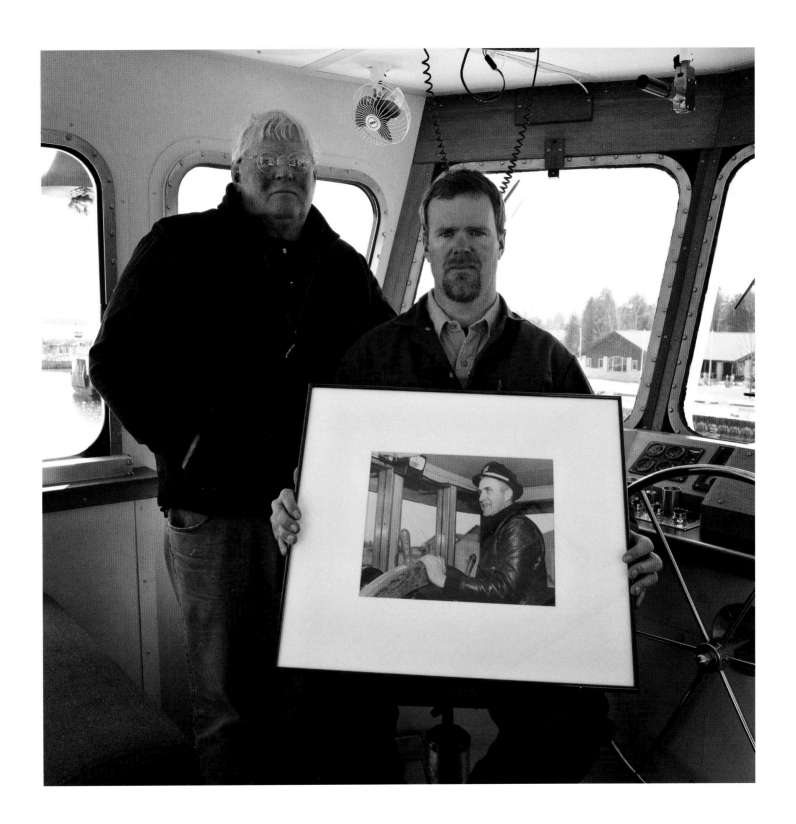

Peters-Weiland & Company
Organ Builders, Milwaukee
Established 1963 by Henry Weiland

Stanton Peters was an apprentice to
the company's original owner, Henry
Weiland. The two men repaired and built
organs at the many churches all around
a city known for its churches. Weiland
died of natural causes in an organ loft a
week before I made this picture.

#3186

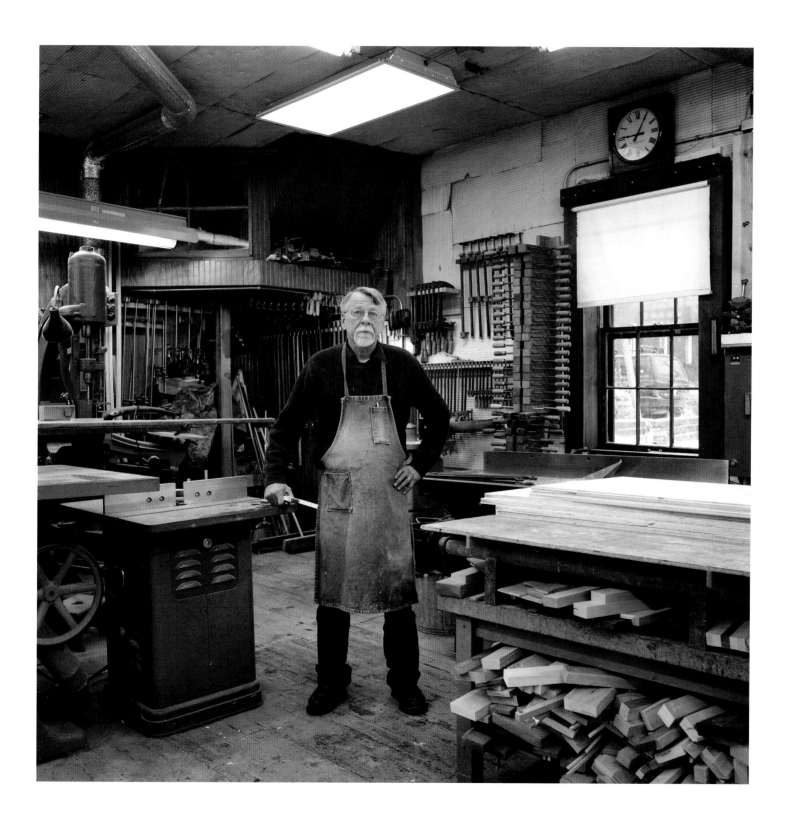

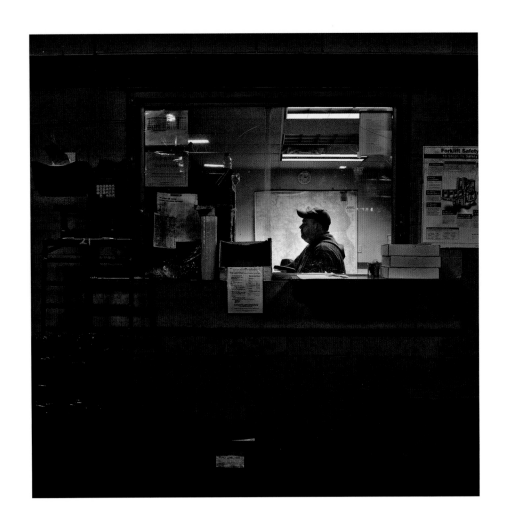

Reliable Plating, Milwaukee
Purchased 1929 by Julian Maliszewski

Reliable Plating offers plating and finishing services for auto and motor-cycle parts and other products. What impressed me most is the attention to detail and pride exhibited at this shop, which is run by Julian Maliszewski's grandsons Jack, Jaime, and Jeff. Logistics manager Greg Hegedus is seen above.

#3178 | #3175

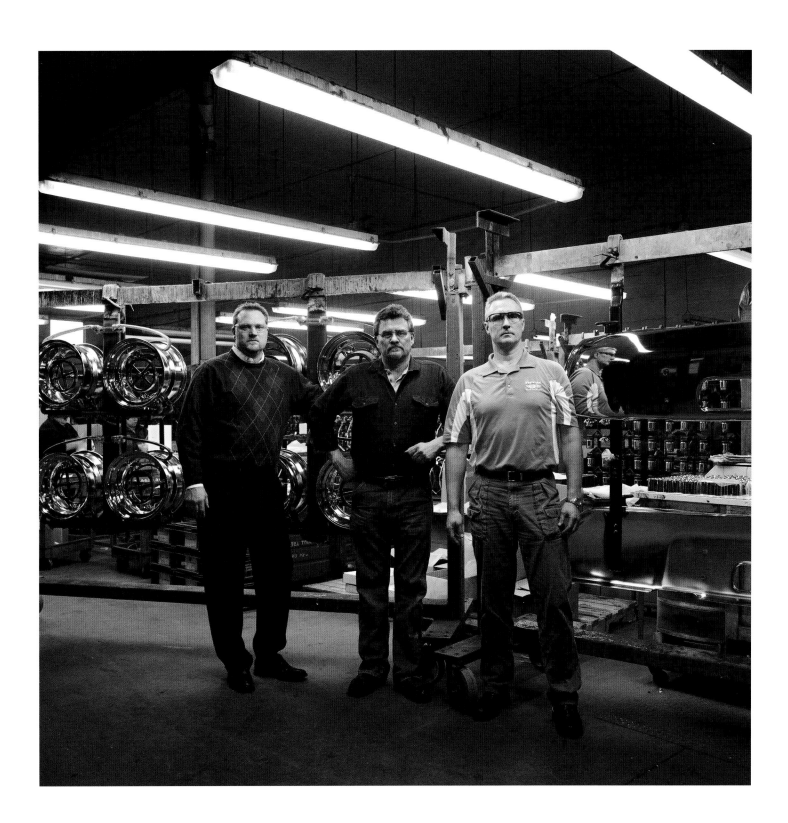

Bossert's Ben Franklin, Mineral Point
Established 1958 by Phil Bossert

Mary Bossert and her late husband, Phil, ran this business together for decades. She makes sure to carry brands and items not available at big-box stores.

#3676

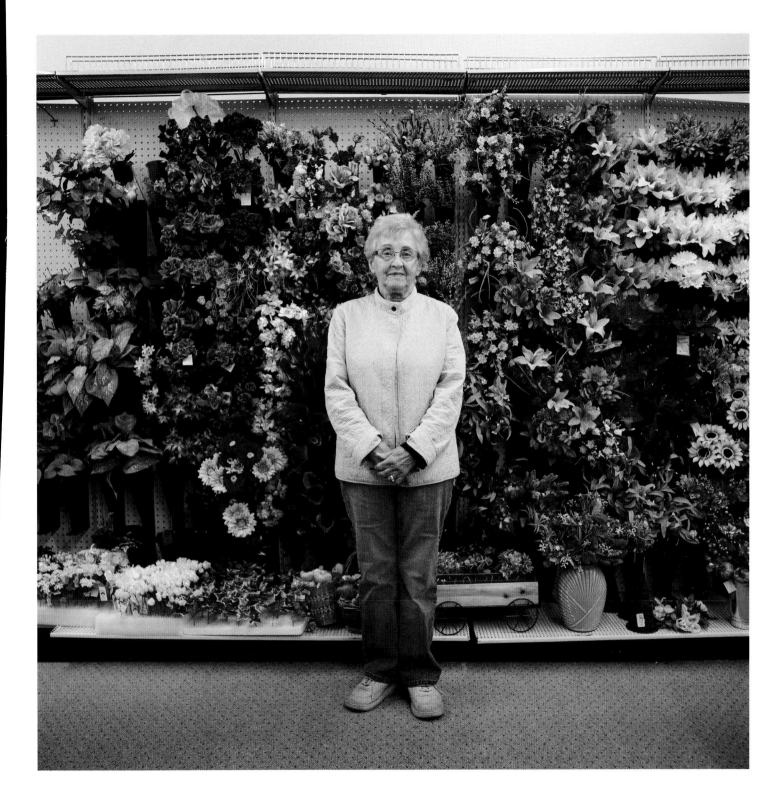

**Sprecher's Bar and Gun Shop,
North Freedom
Established 1900 by Edwin
Sprecher Sr.**

Junior Sprecher was in his nineties
when I made this picture. He was born
in the apartment attached to the rear
of the bar and still lives there.

#3527

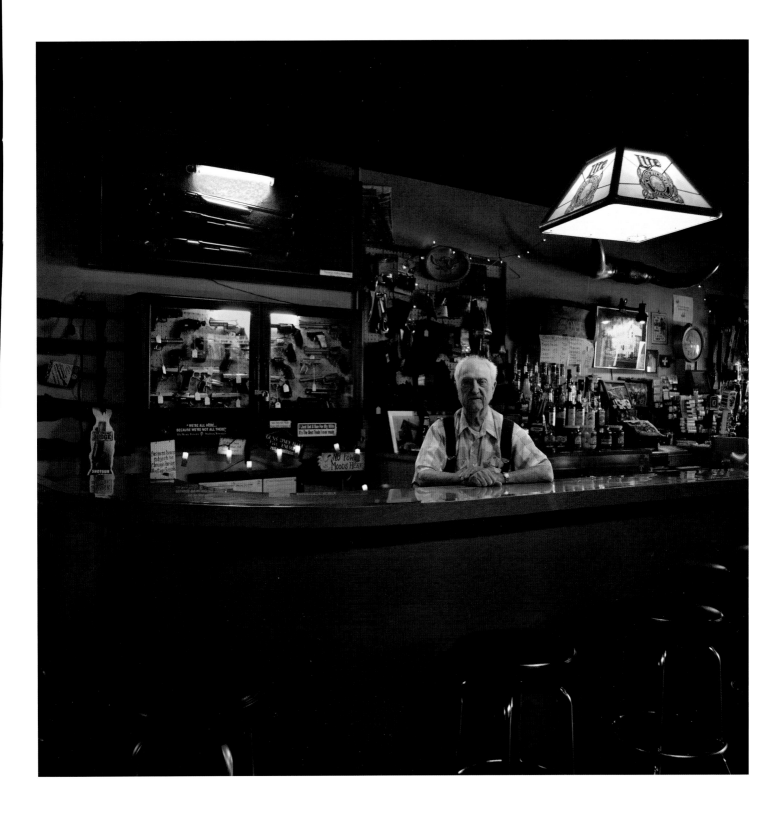

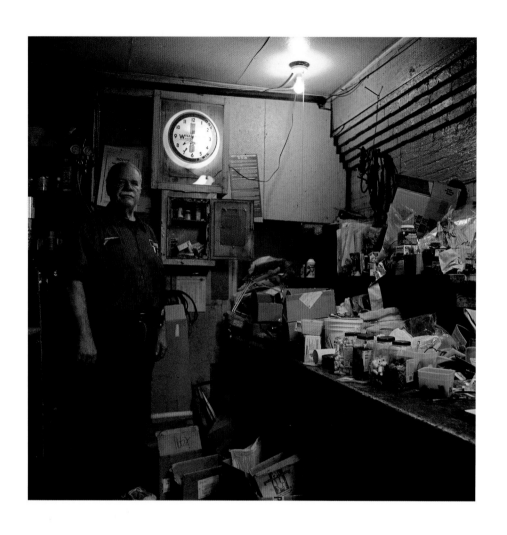

H.G. Thill and Sons HVAC, Marinette
Established 1944 by Harold Thill

Jim Thill runs the company started by
his grandfather Harold.

#3139 | #3141

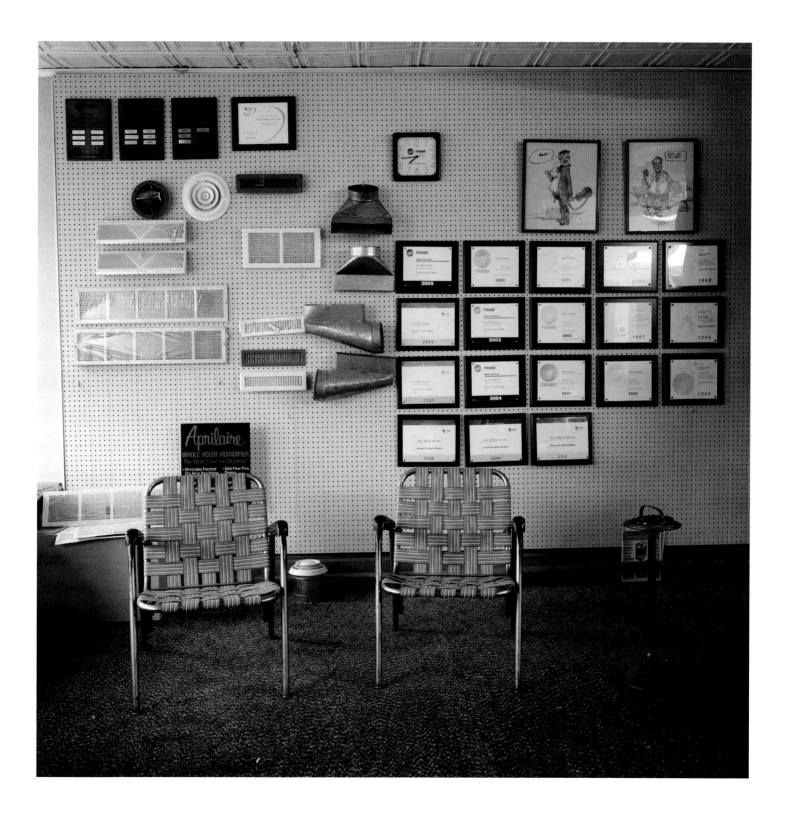

C.J. Meiselwitz Furniture, Kiel
Established 1898 by Carl J. Meiselwitz

Bill Curry and his son Mike sit in a display
window at the family's store, which was
started as a furniture and funeral home
business by Carl Meiselwitz, an ancestor
on Bill's wife's side of the family.

#3905

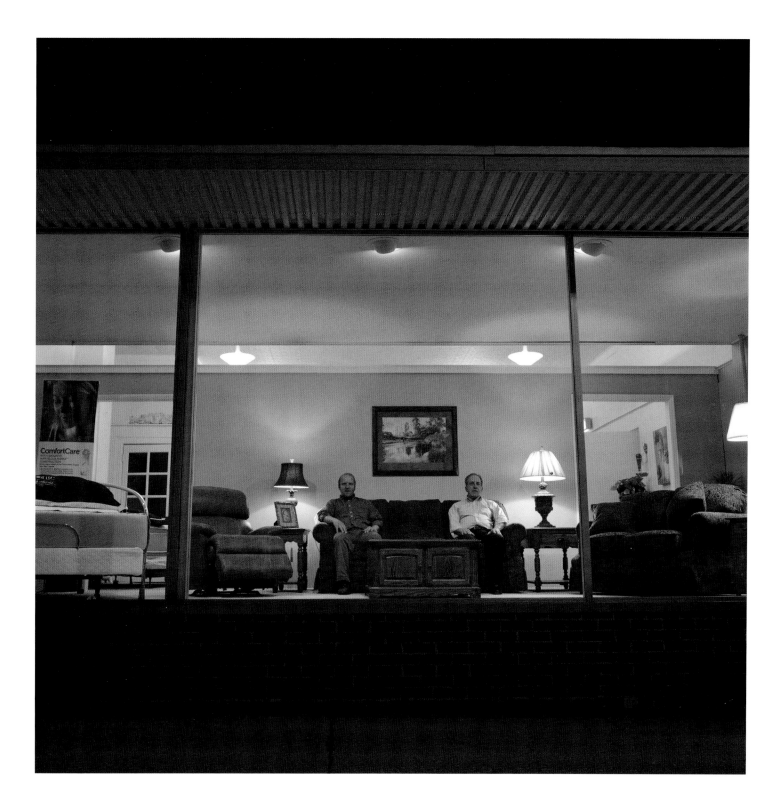

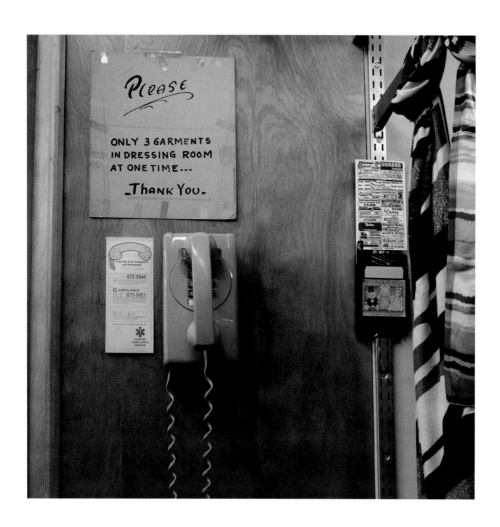

Wolf's Ladies Apparel, Durand
Established 1904 by Frank Fox

Wolf's is run today by Susan Wolf,
a great-granddaughter of the founder,
Austrian immigrant Frank Fox. At right
is longtime employee Julie Robelia.

#3870 | #3869

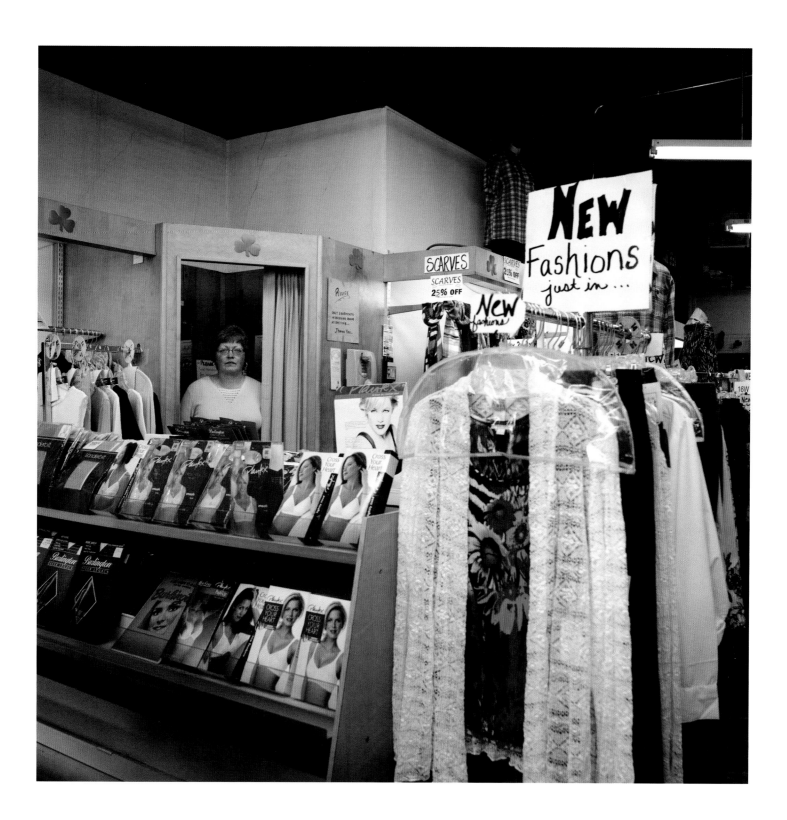

Anderson Fishery, Gills Rock
Established 1941 by Alvin Anderson

At age eight, Alvin Anderson (right) was the first deckhand on this very fishing boat, the *Alicia Rae*. A generation later his son Dan (left) slept in a net box on the boat while his parents, Alvin and Sandy, worked. Dan does most of the company's commercial fishing in Alaska now, but he returns every spring to fish with his father in the original boat.

#3982

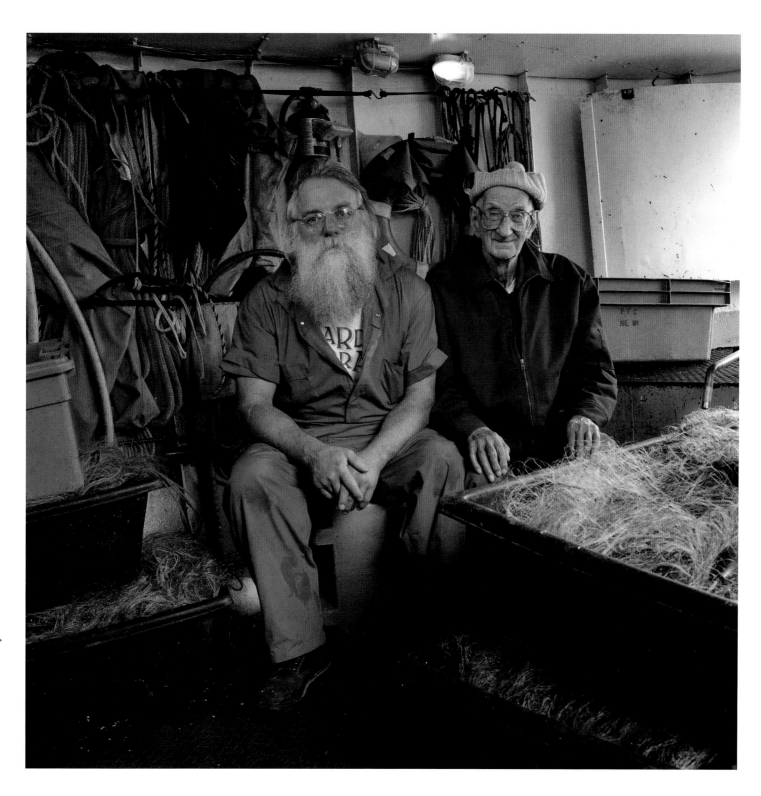

Wolski's Tavern, Milwaukee
Established 1908 by Bernie Wolski

Brothers Mike, Bernie, and Dennis Bondar,
great-grandsons of the founder. Better
hosts you'll never meet. These guys love
being bar owners, and it shows.

#3164

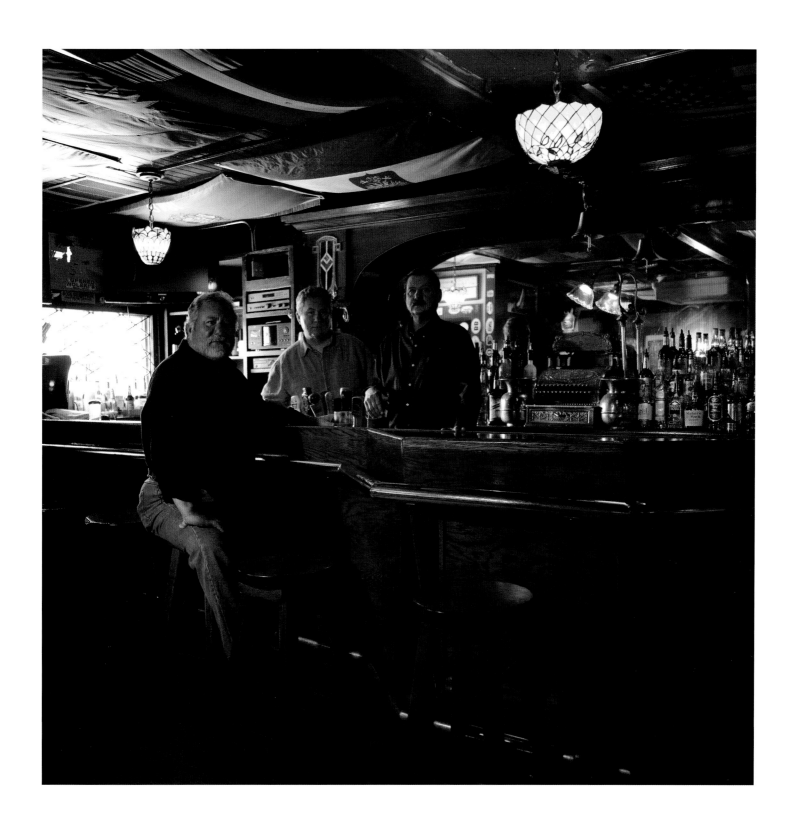

Evans Variety Store, Kiel
Established 1936 in Sheboygan
by Demo and Lucia Evanoff;
Kiel store opened in 1950

Ed Evanoff wants to be sure that he has in his inventory just what the customer wants. He usually does.

#3900

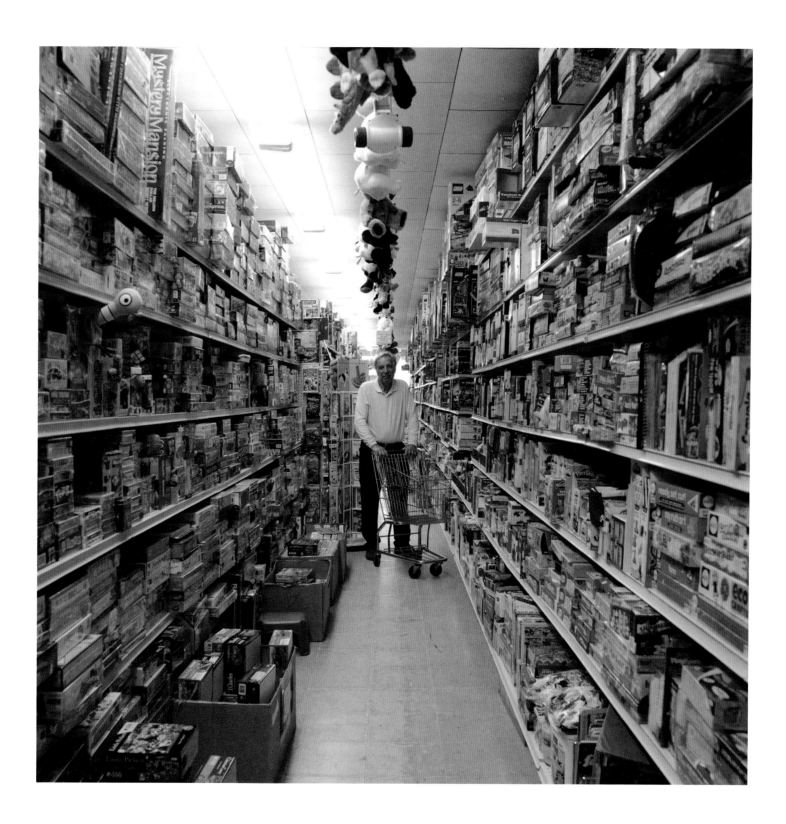

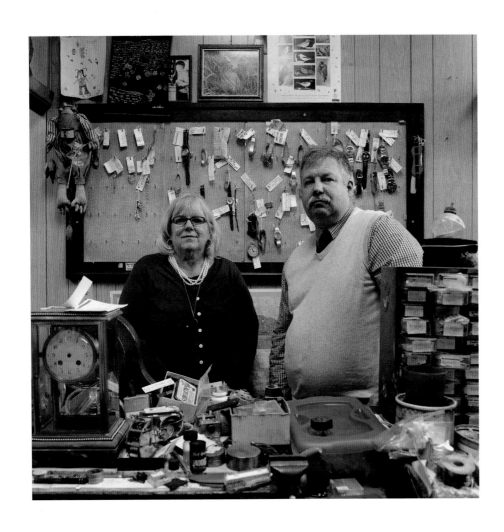

Nummi Jewelers, Superior
Established 1951 by Harry Nummi

Siblings Karen Nelson and Dale Nummi
run Nummi Jewelers, which was founded
by their father, Harry, a watchmaker.
After his retirement Harry Nummi con-
tinued working at the store until a week
before his death at age ninety-two.

#3942 | #3947

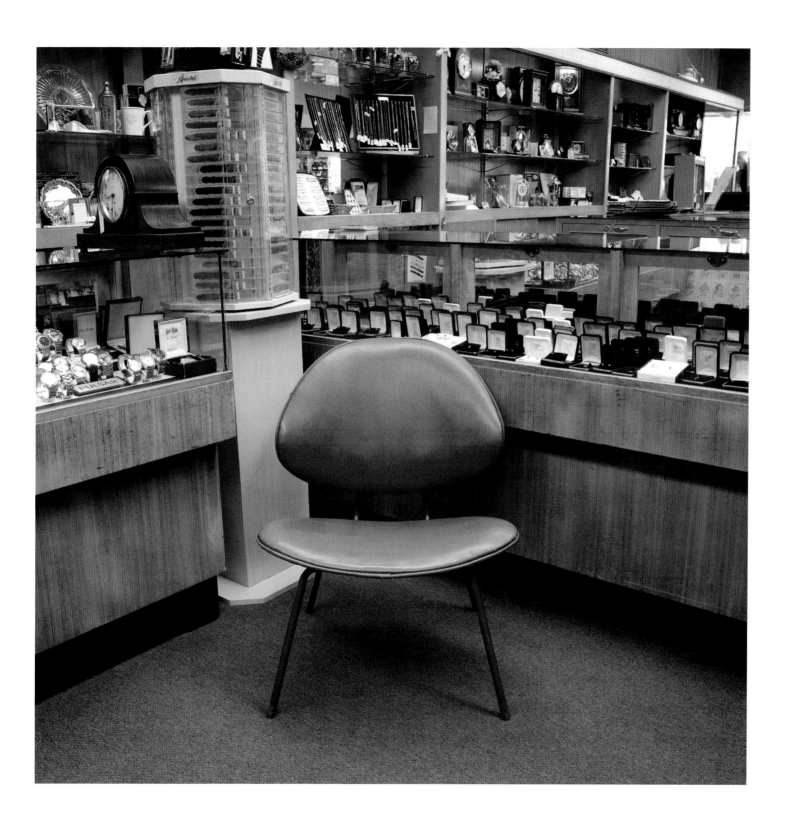

Ryan Brothers Ambulance Service, Madison
Established 1962 by Pat and Paul Ryan

There was no 911 system when the Ryan brothers started an ambulance service in their father's funeral home business. The company is run today by founder Pat's sons, Patrick, shown here, and Erin.

#3522

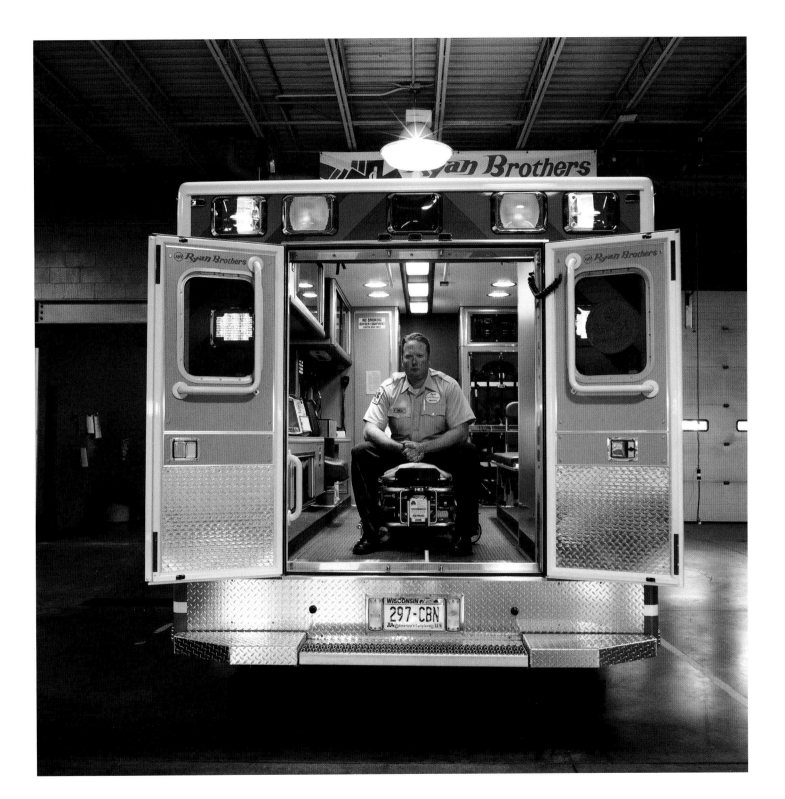

McCluskey Brothers Organic Farms, Hillpoint
Established 1888

Brothers Pat (left) and Brian (right) McCluskey with nephew Peter. Along with maple syrup, the McCluskeys produce organic, grass-fed beef and cheese at their farm, which their Irish ancestors named Shillelagh Glen.

#3934

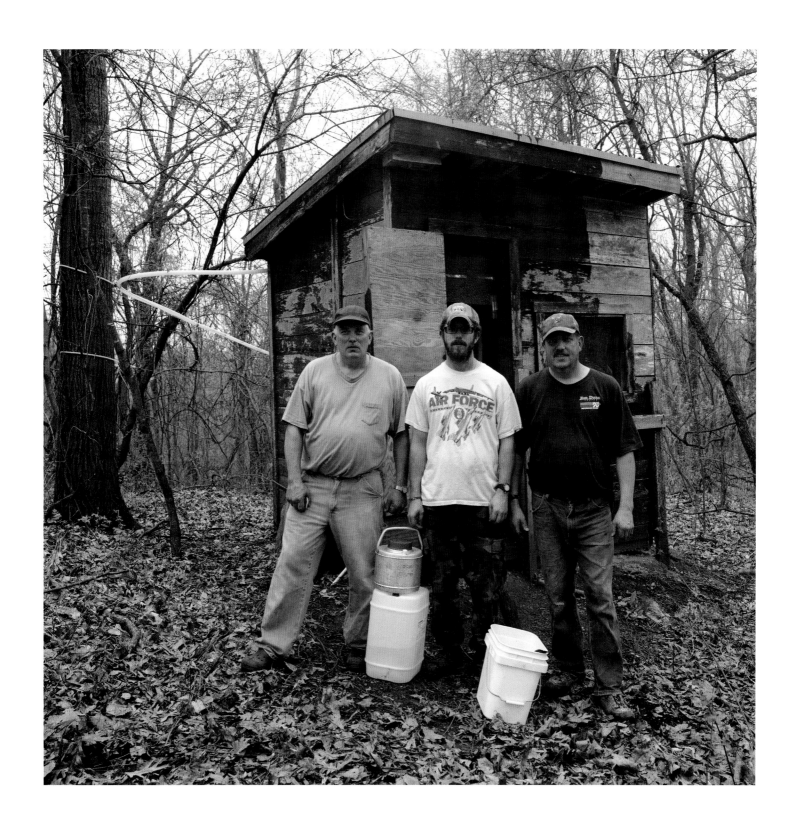

**Panka Shoe Store, Prairie du Chien
Established 1919 by Peter Panka**

Theresa Mezera, who bought the shoe
store from her cousin Antoinette Panka,
has been visited by Japanese buyers
many times. She has inventory dating
back to the 1960s, and she knows
precisely where everything is.

#3581

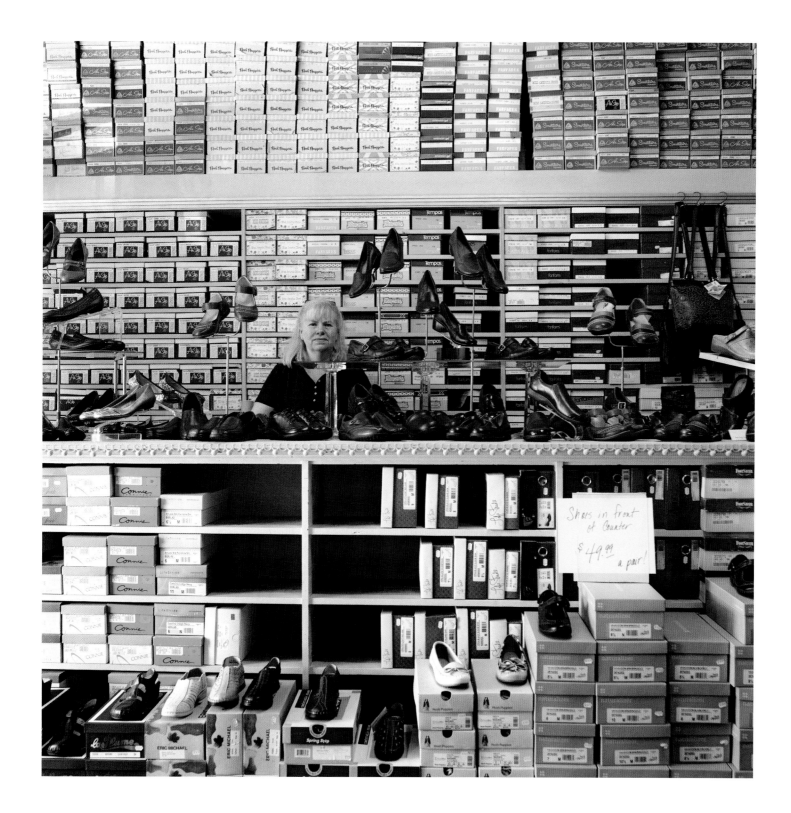

**A.O. Johnson and Sons
Hardware, Phillips
Established 1928 by
Arthur Oswald Johnson**

Brady Johnson's tattoo shows his pride
in the business his great-grandfather
Arthur started in 1928.

#3629

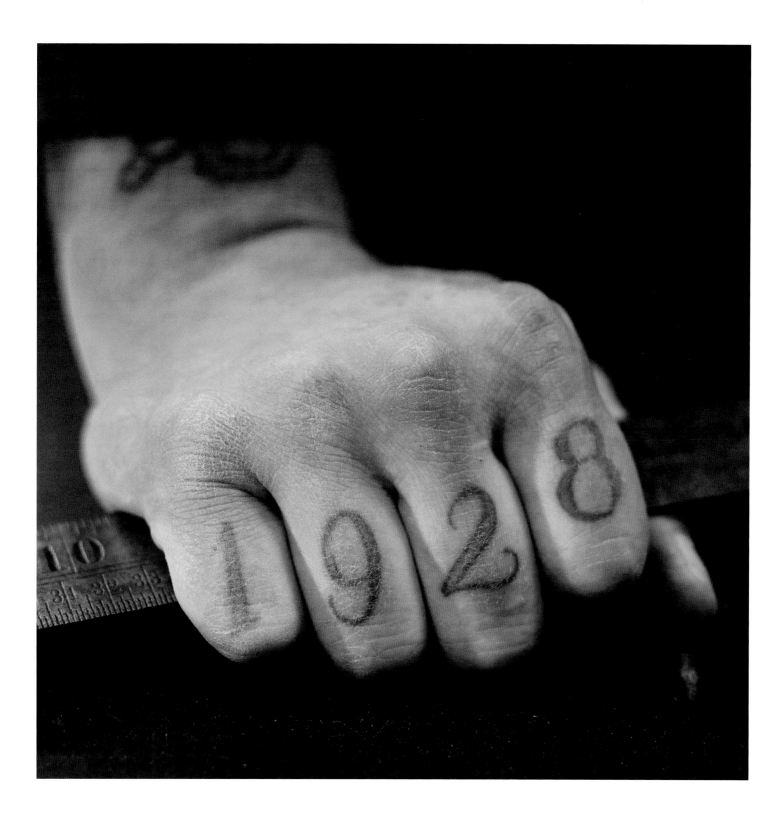

**A.O. Johnson and Sons
Hardware, Phillips
Established 1928 by
Arthur Oswald Johnson**

When I met him, Brady Johnson had
recently returned from the Iraq War.
He said he was thankful to be back at
work at the store.

#3628

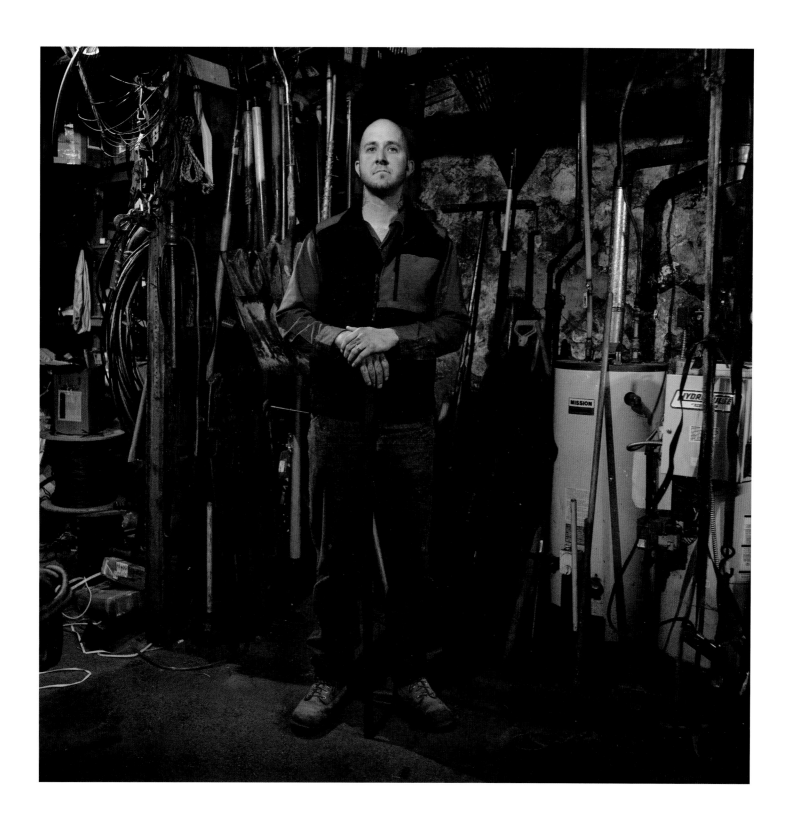

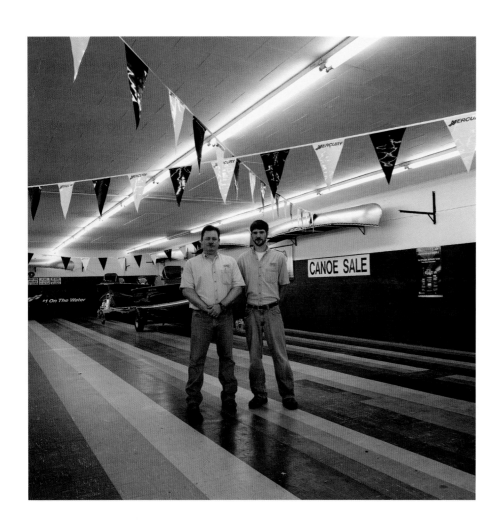

**Stark's Sport Shop and Liquor,
Prairie du Chien
Established 1944 by Frank Stark**

Randy Stark and his son, Alex, in the
boat showroom of the store started
by Randy's grandfather Frank. Along
with Mercuries and Alumacrafts, they
sell beef jerky, cheese, beer, wine, and
"the best ice around."

#3604 | #3597

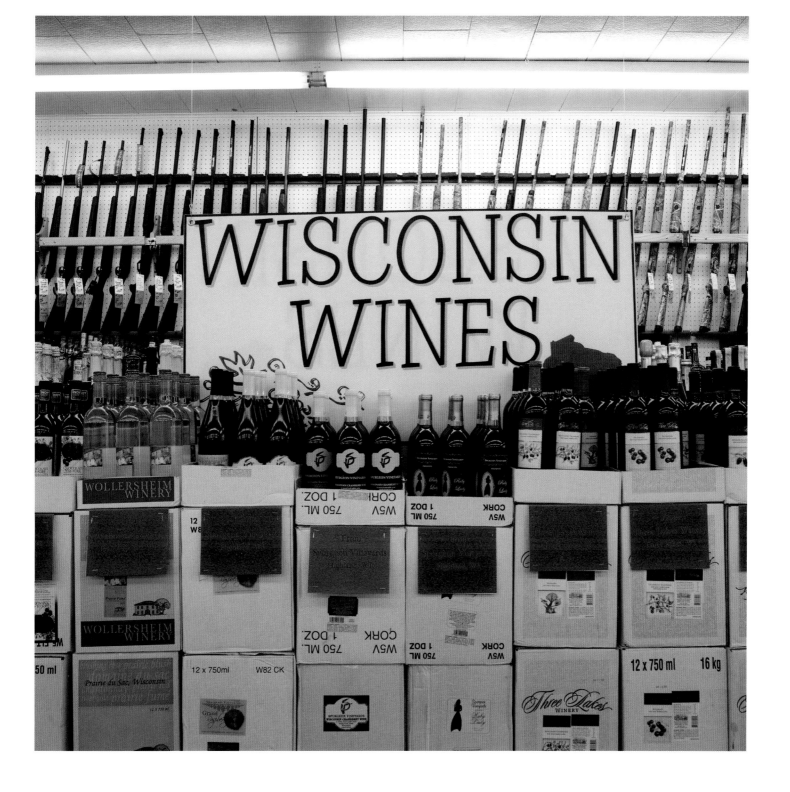

Carr Valley Cheese, LaValle
Established 1902

Master cheesemaker Sid Cook began
making cheese as a child, but his
cheesemaking lineage goes back
much further—more than 125 years.
His mother's family started one of the
first cheese plants in Vernon County.

#3695

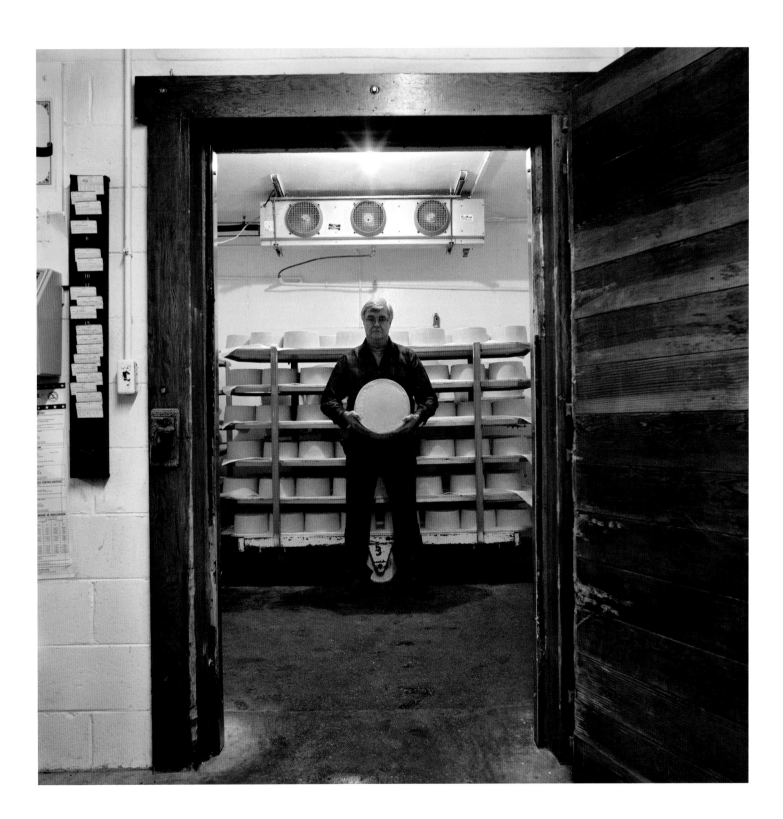

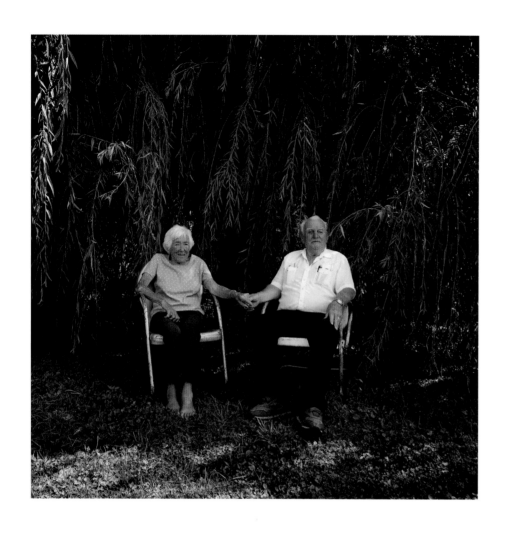

**Double K-D Ranch
Campground, Baraboo
Established 1964 by
Bud and Ardice Cady**

Ardice and Bud had been married sixty-five years when she died in February 2013. Today their children, Ken Cady and Marilyn (Cady) Nechvatal, along with Marilyn's daughter Brittany, run the campground. Bud told me he hopes to be around in 2014 for the Double K-D's fiftieth anniversary celebration because "it's lots better than the alternative." At right, a collage of past guests greets visitors to Double K-D Ranch.

#3520 | #3517

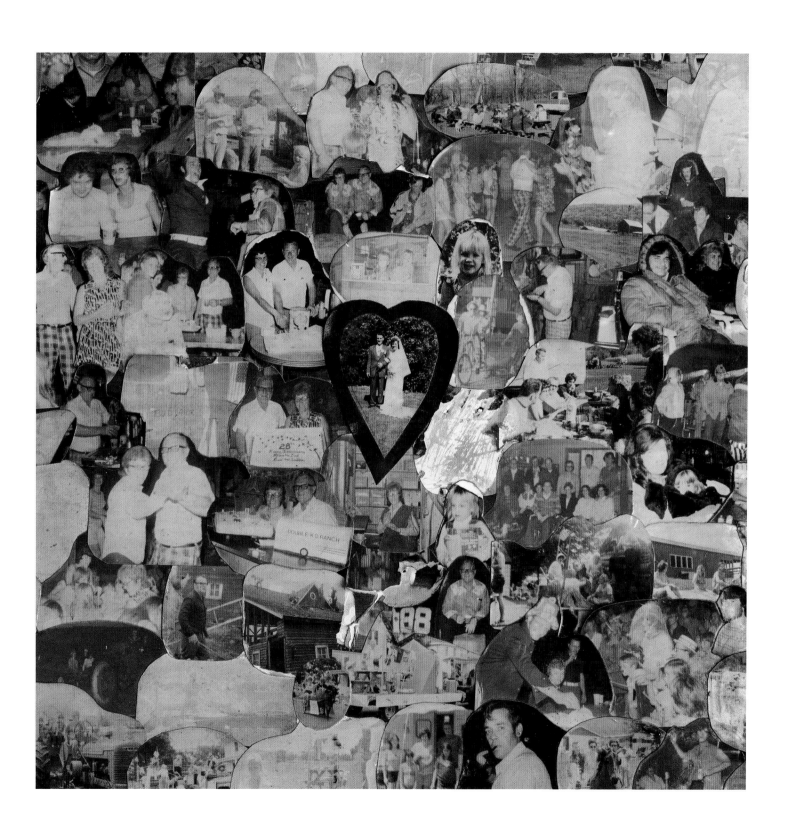

The Kitchen, Superior
Established 1950

Ed Flood, co-owner with his wife, Theresa, brought The Kitchen from Theresa's aunt Patricia Kenville in 2005. Ed cooks every day they're open.

#3955

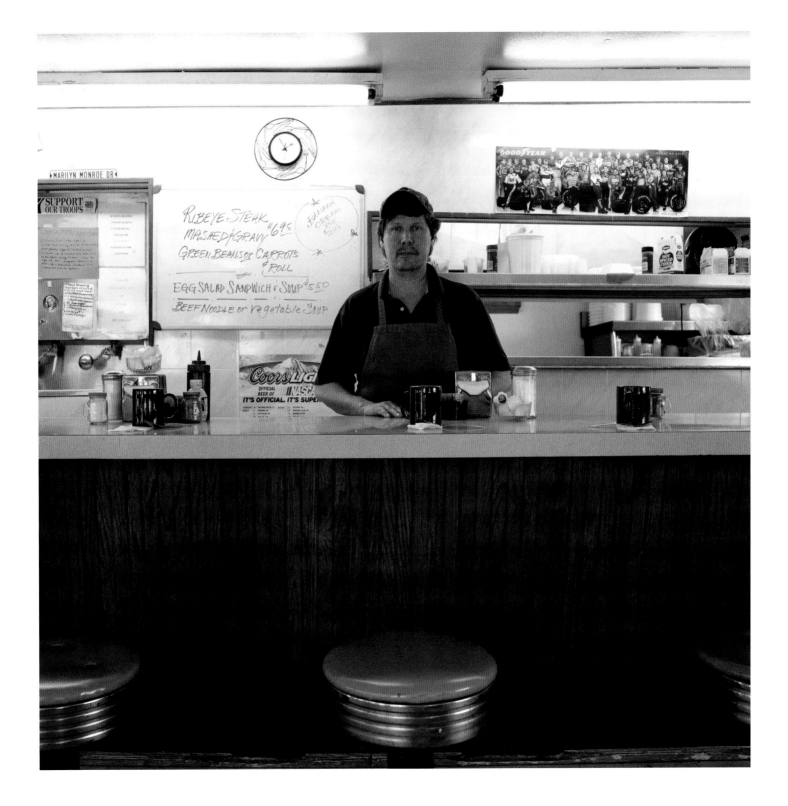

The Kitchen, Superior
Established 1950

Chris has been a waitress at
The Kitchen for seven years.

#3953

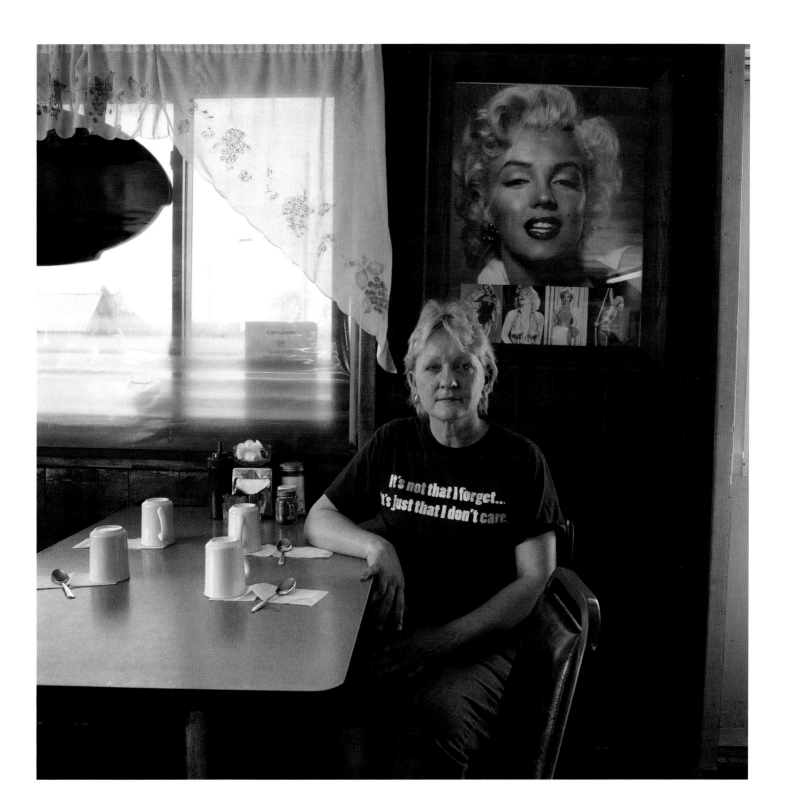

**Gorgen Funeral Home, Mineral Point
Established 1916 by Philip and
Mary Gorgen**

Greg Gorgen (center) and sons Grant
and Mike run the business started by
Greg's grandparents. Mary Gorgen was
one of the first licensed women funeral
directors in Wisconsin.

#3664

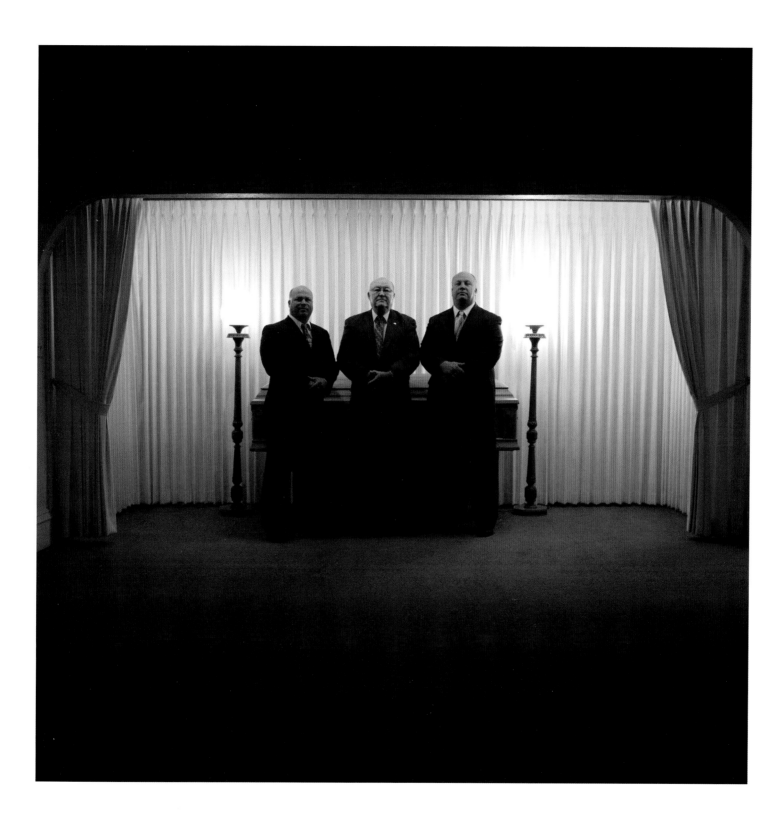

Grimm Book Bindery, Monona
Established in Madison 1874 by
Gottlieb Grimm

Bill Grimm is the great, great-grandson
of company founder Gottlieb Grimm,
a German bookbinder who learned the
craft from his father and immigrated
to America in 1849. I hear the original
bindery building in Madison is haunted.

#3214

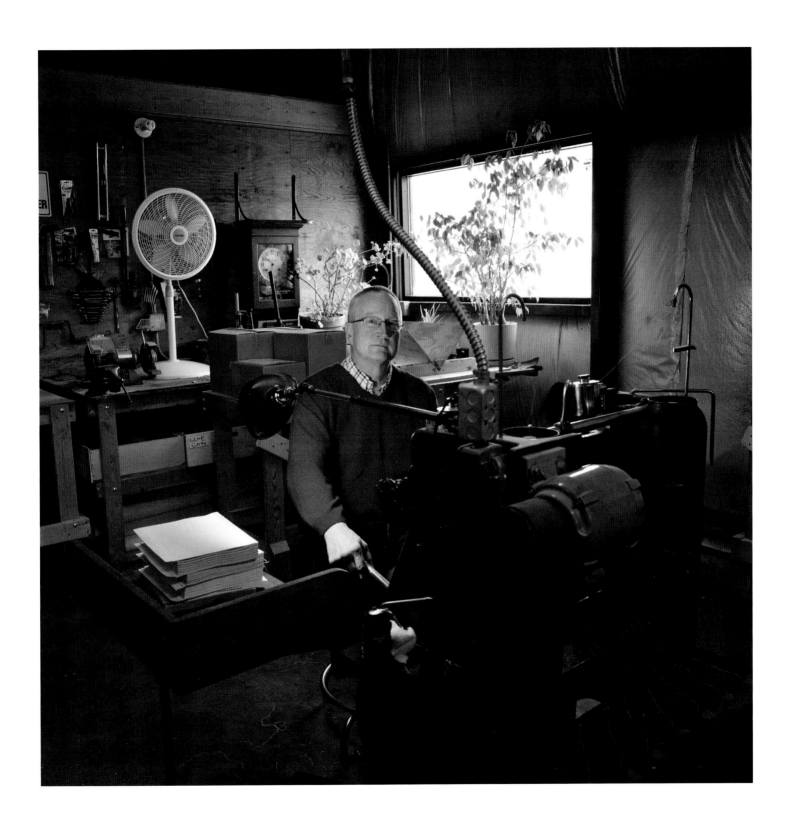

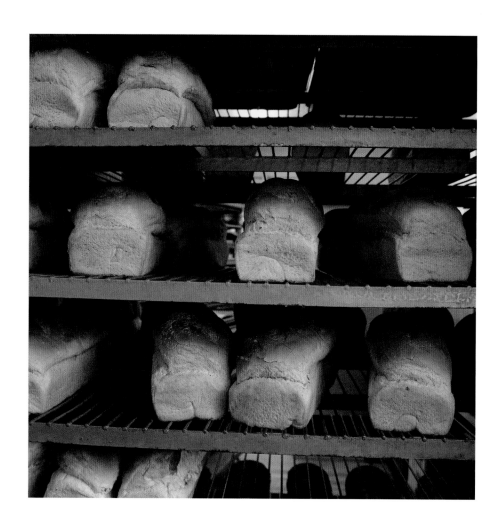

Roeck's Bakery, Kiel
Established 1908 by Christy Roeck

Behind owner Jared Roeck is the oven his grandfather Leon installed. My favorite at Roeck's is the poppy seed coffee cake, or maybe the peanut crunch bar. The almond crescents were fabulous, as were the cheese Danish.

#3927 | #3929

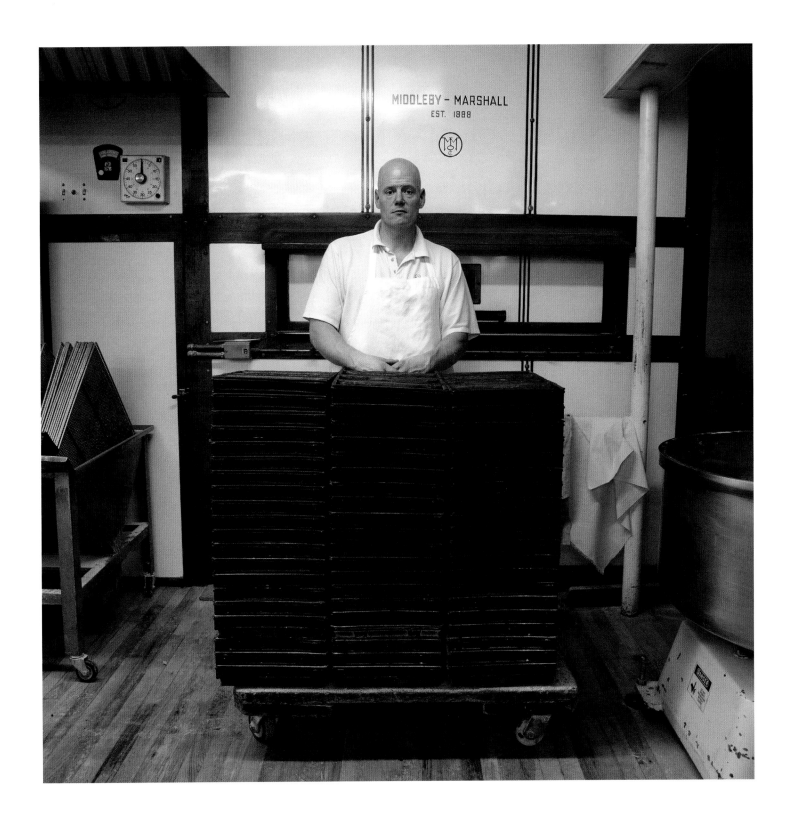

Speed Queen BBQ, Milwaukee
Established 1956 by Betty Gillespie
and Leonard Partee

Glynis Smith and the crew at Speed
Queen make great BBQ. Her mother,
cofounder Betty Gillespie, made "the
closest thing to barbecue heaven this
far north," the *Milwaukee Journal* once
said. Today Glynis runs the business
with Giovanni Gillespie, Betty's son.

#4203

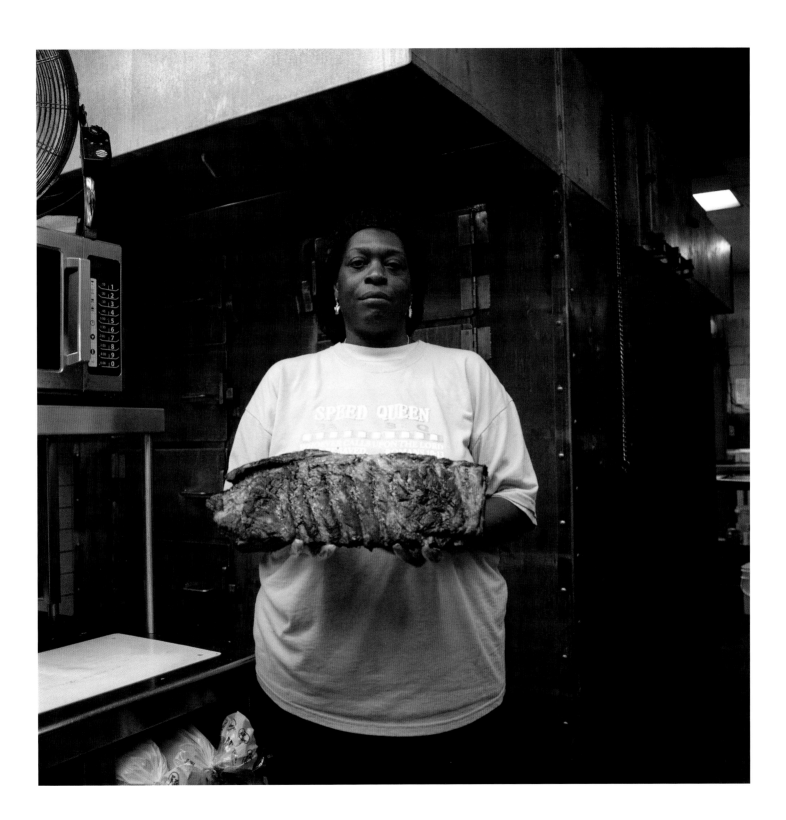

Schoenborn's Jewelry, Kiel
Established 1905 by Matt Schoenborn

Bob Schoenborn is a proud and amiable
master watch technician. His grandfather
started the business on the family farm.

#3874

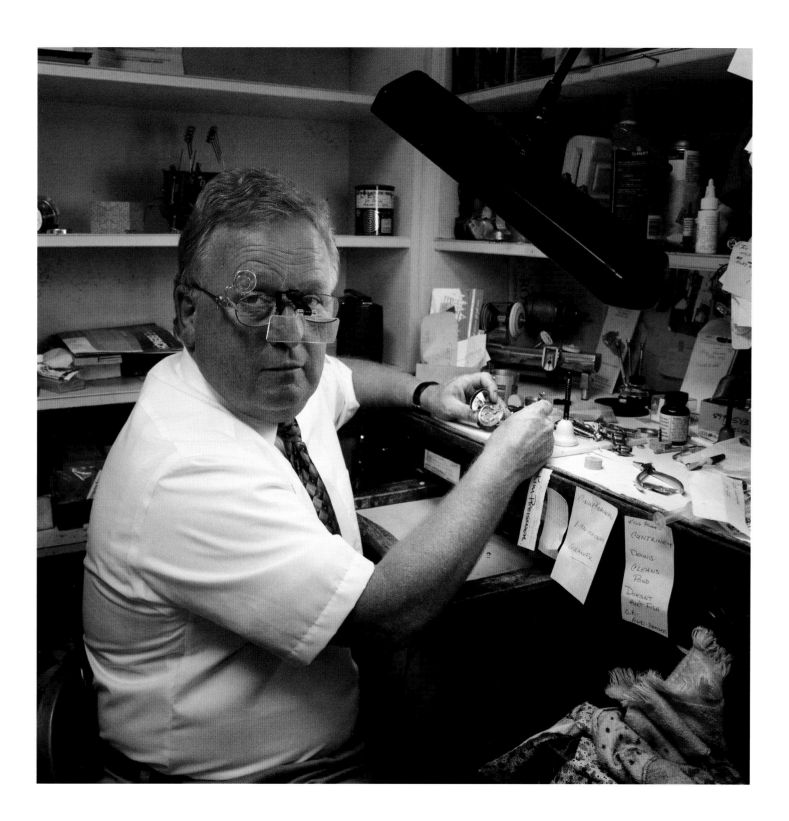

Superior Lidgerwood Mundy, Superior
Established 1895 as Superior Iron Works
by Frank Hayes

SLM makes hoists and cables for the
marine industry—BIG stuff. I was there
on machine lathe operator Brent's last
full day of work before retirement.
Brent is going fishing . . . every day.

#3974

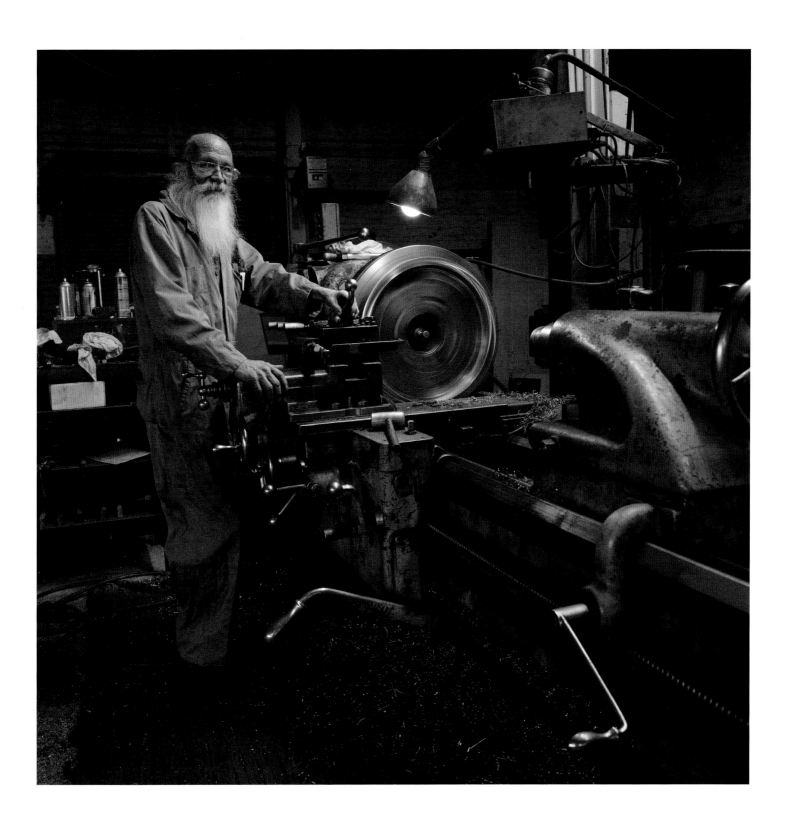

Janke Book Store, Wausau
Established 1919 by Carl Janke and
Reno Kurth

Janke Book Store, run by Carl Janke's
grandchildren Jim Janke and Jane
Janke Johnson, is known for its com-
munity involvement and knowledgeable
staff members. Employee Karen Briggs,
pictured here, happens to have been
Jane's seventh grade math teacher.

#3727

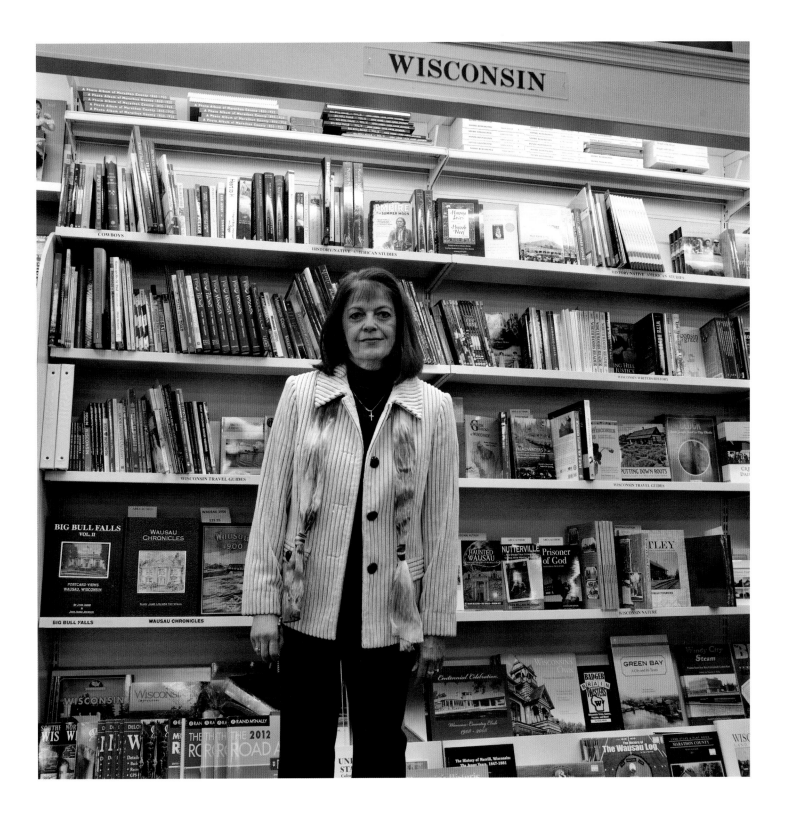

Lulloff Hardware, Kiel
Established 1920 by Herman Lulloff

Joel Lulloff (right), his brother, Eric
(left), and Joel's son Jason (center)
run a true old-fashioned hardware store,
providing services and selling goods
from washing machines to feed.

#3880

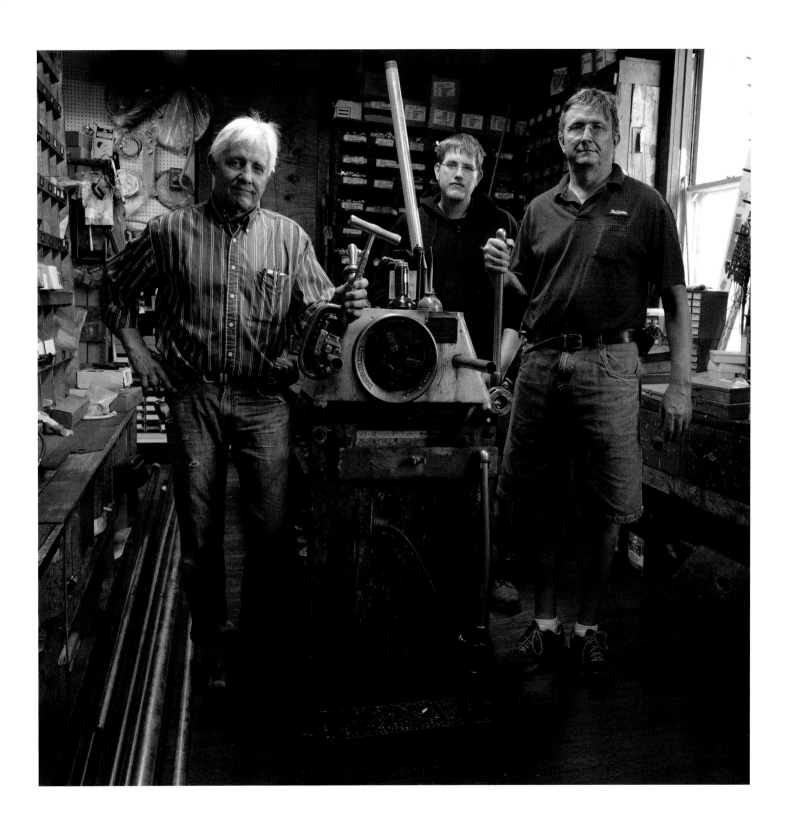

**Lauerman's Home Furnishings, Marinette
Established 1890 by Joseph A.J.
Lauerman and Frank Lauerman**

Henry Lauerman Jr. (right) and his son,
Scott, run the last descendent of a
department store enterprise that began
in 1890 as Lauerman Brothers Savings
Bank, started by Henry's grandfather Joe
and granduncle Frank.

#3124

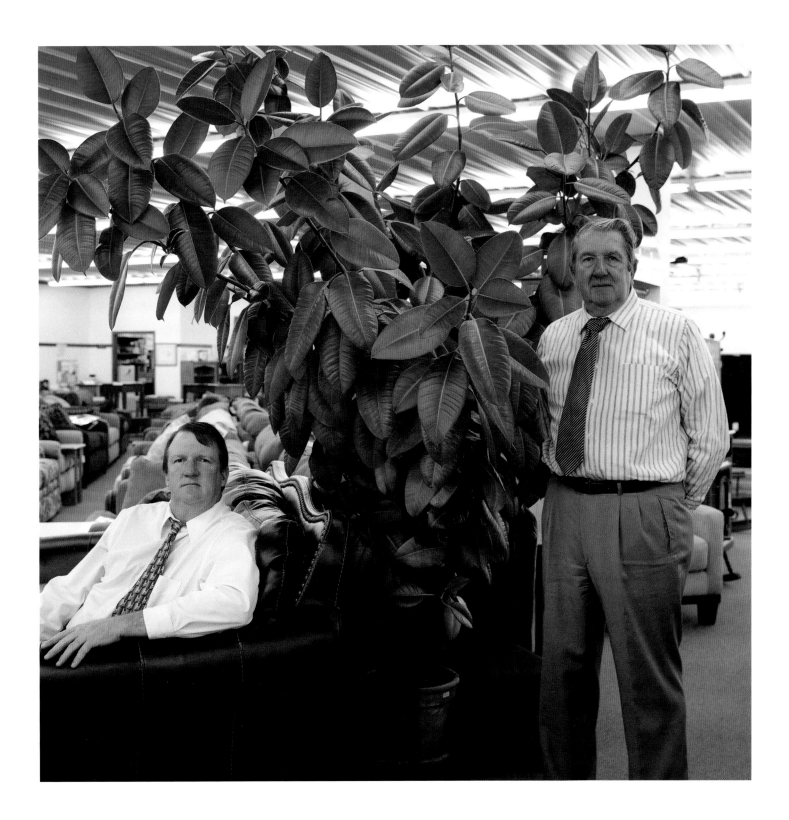

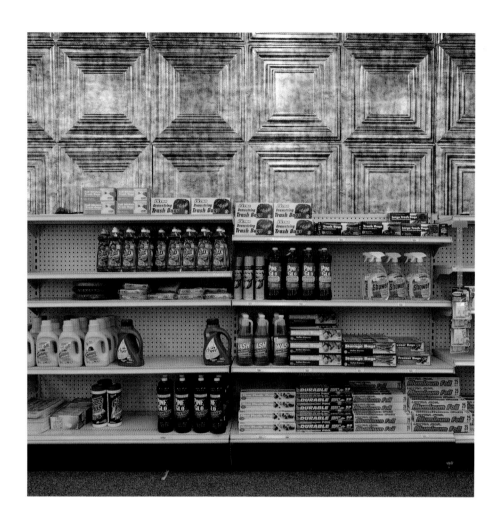

Peoples Pharmacy, Superior
Established circa 1933 by John Olsen

Both owner Jeff Eliason (left) and
employee Art Haugen are pharmacists.
In addition to refilling their prescriptions,
Peoples Pharmacy offers its customers
a wide variety of goods.

#3950 | #3949

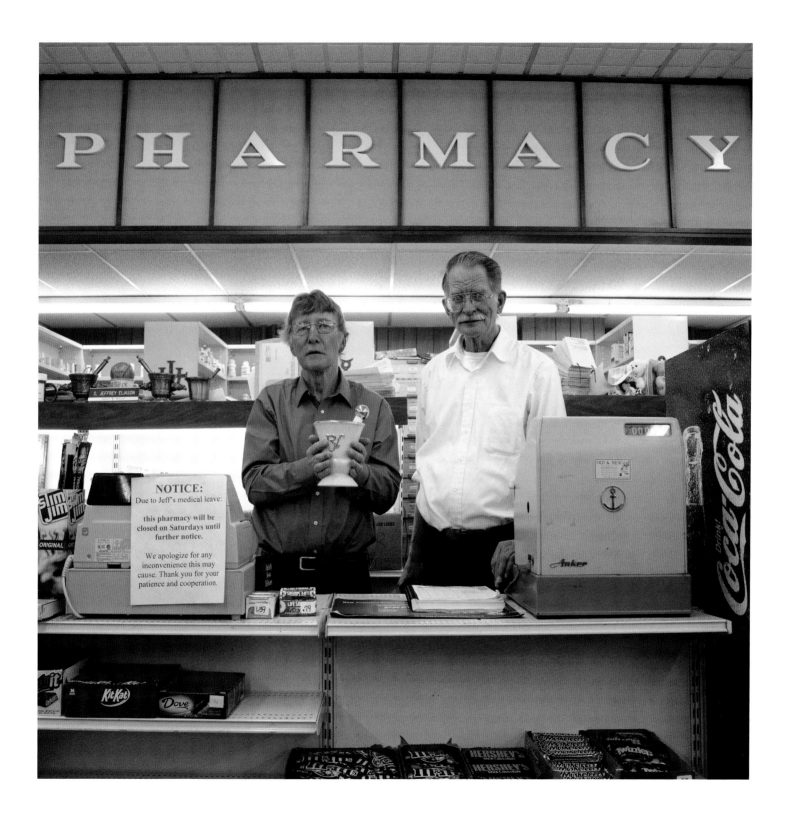

NOTICE:
Due to Jeff's medical leave:

this pharmacy will be
closed on Saturdays until
further notice.

We apologize for any
inconvenience this may
cause. Thank you for your
patience and cooperation.

Nick's Restaurant, Madison
Established 1959 by Arist Christ

Brothers Tim (left) and Constantine
"Dino" Christ run the restaurant
started by their dad. Great lemon pie
can be had here.

#3641

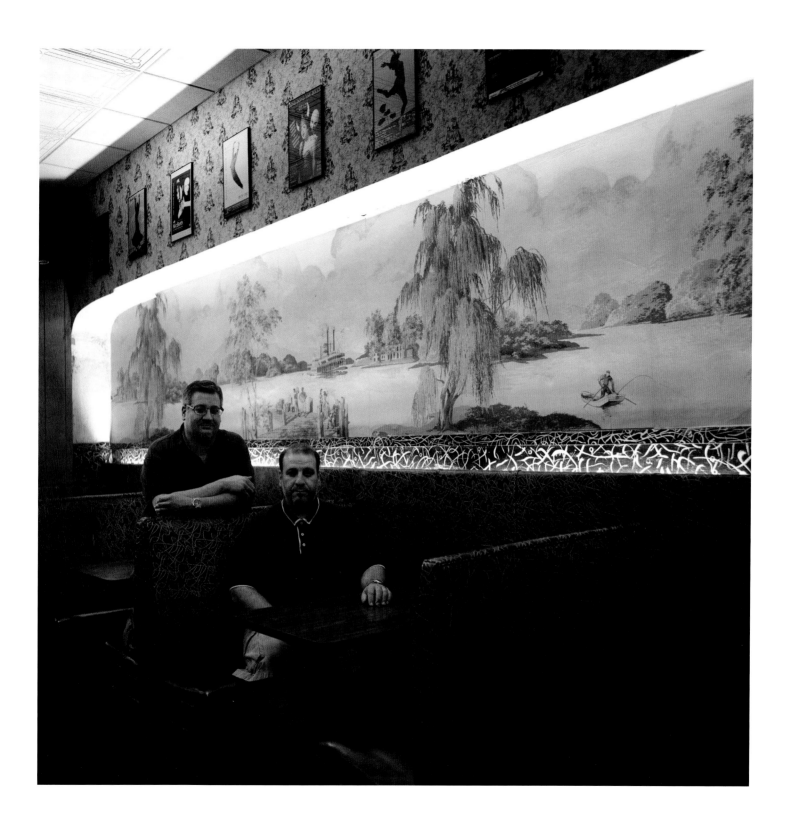

Afterglow Resort, Phelps
Established 1949 by Bert Moline

Pete and Gail Moline own and run the
Afterglow, started by Pete's father.
A former professional moguls skier,
Pete grooms Afterglow Resort's eleven
miles of ski trails.

#3101

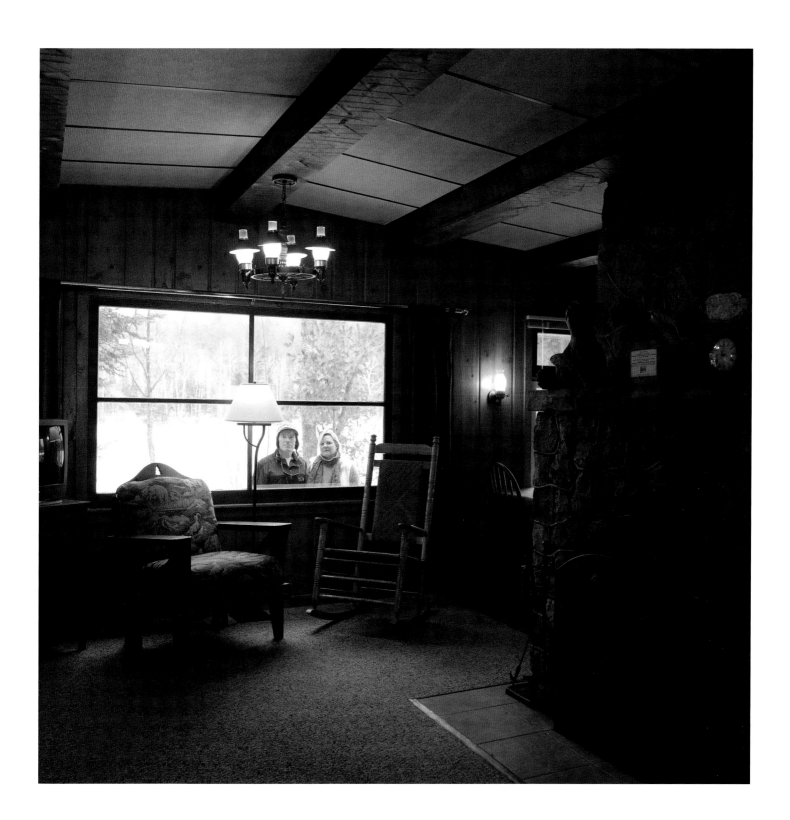

Drees Electric, Marinette
Established 1946 by Lawrence Drees

Repairman Bill Meyst remembers when
TVs were repaired instead of being
dumped in landfills. Drees Electric
still does repair work on televisions
and appliances. The company is run
by founder Lawrence's son Jack and
grandson Tom.

#3105

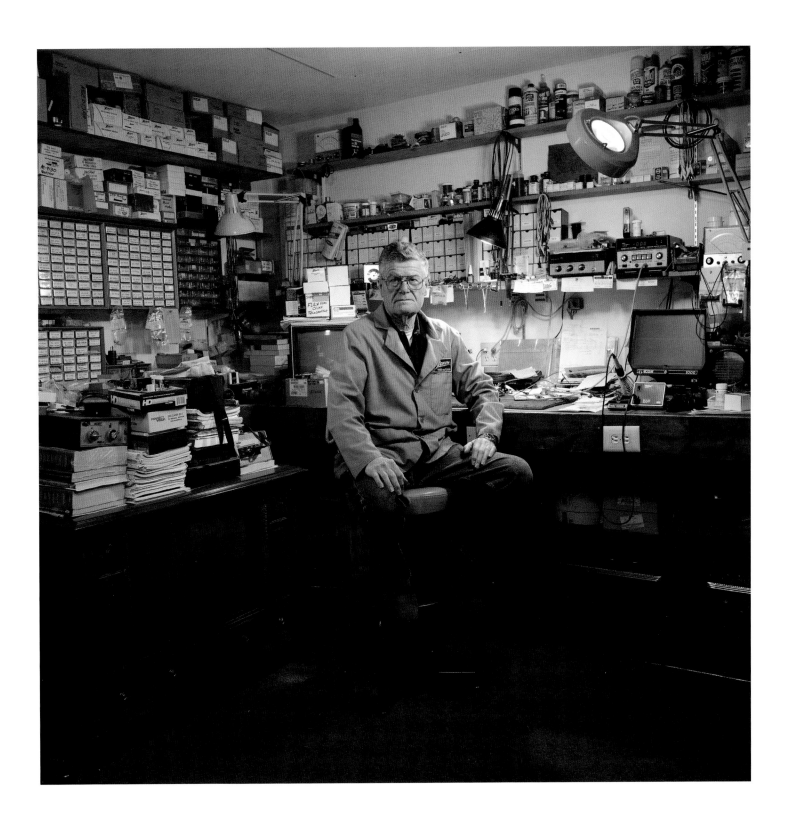

Charlie's Smokehouse, Gills Rock
Established 1932 by Roy Voight

Charlie Voight and son Chris told me there is no longer commercial fishing of salmon or trout in Lake Michigan; these fish are brought in from the Atlantic and Pacific. Their whitefish, though, comes from local waters—and it is excellent. Charlie's dad, Roy, started the business selling smoked chubs to tourists and using a cigar box for a cash register.

#3981

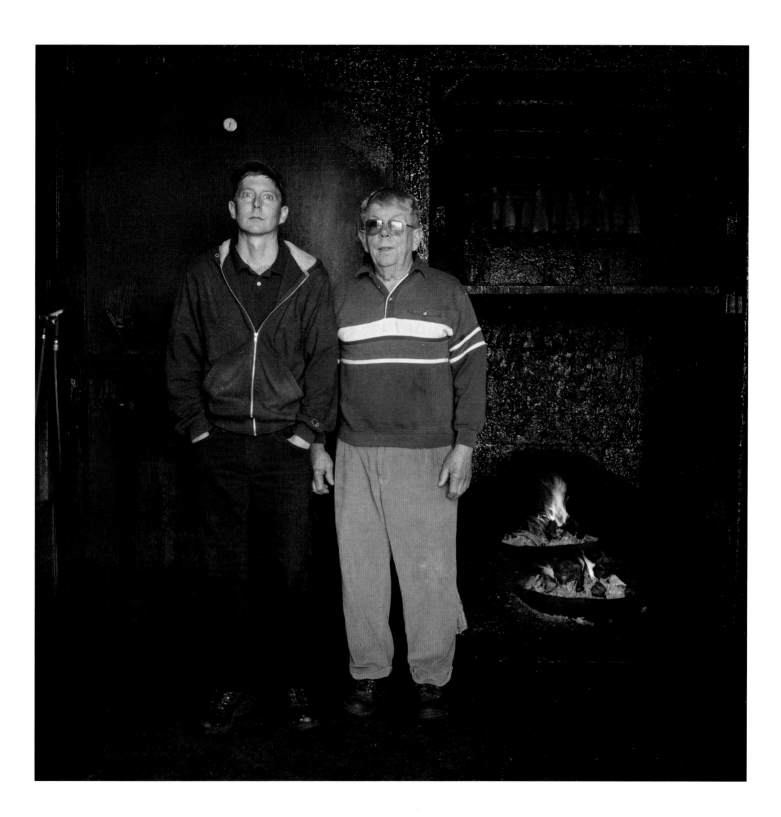

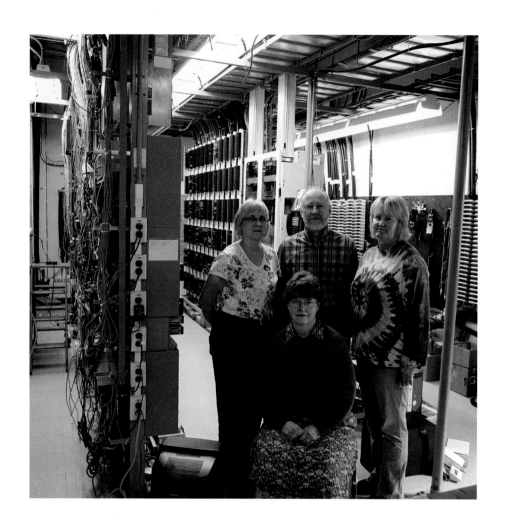

Price County Telephone, Phillips
Established 1900 by H.P. Proctor

Price County Telephone, which serves communities all around Price County, was bought by Karl E. Mess in 1913. The company is run today by his grandchildren. Left to right are Catherine Mess, John G. Mess, Carol Mess Kuzma, and Barbara Mess Gago. Dwight Simpson, at right, is the central office supervisor. He's worked there since 1974.

#3612 | #3613

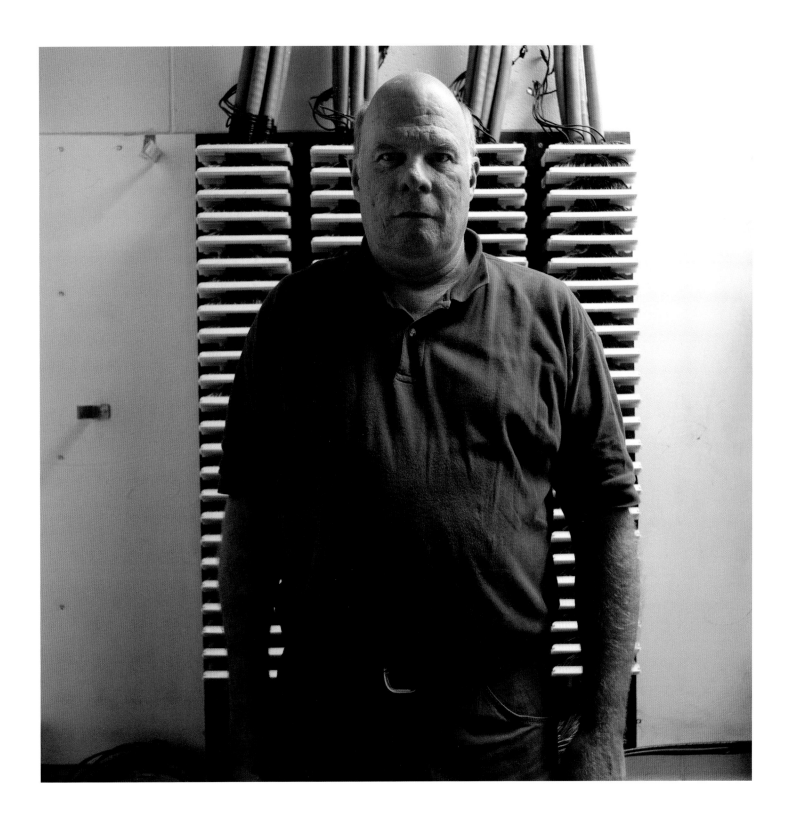

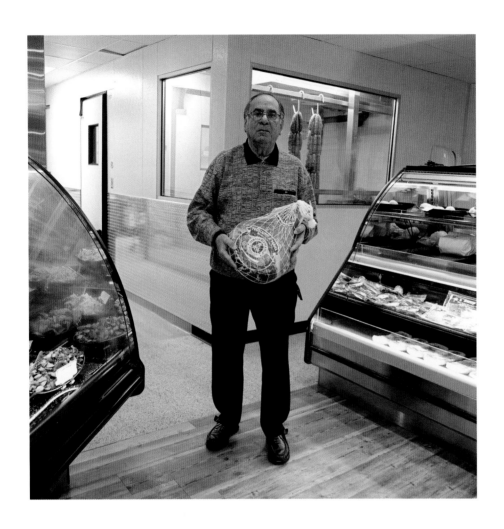

**Glorioso's Italian Foods, Milwaukee
Established 1946 by Joe, Ted,
and Eddie Glorioso**

Glorioso's makes great Italian beefs
and the best cannoli I've ever had. Most
days you'll find Ted (above) or another
of the founding brothers in the store
talking to customers in English and
Italian. At right, employee Bill shows
off fresh handmade sausages.

#3174 | #3170

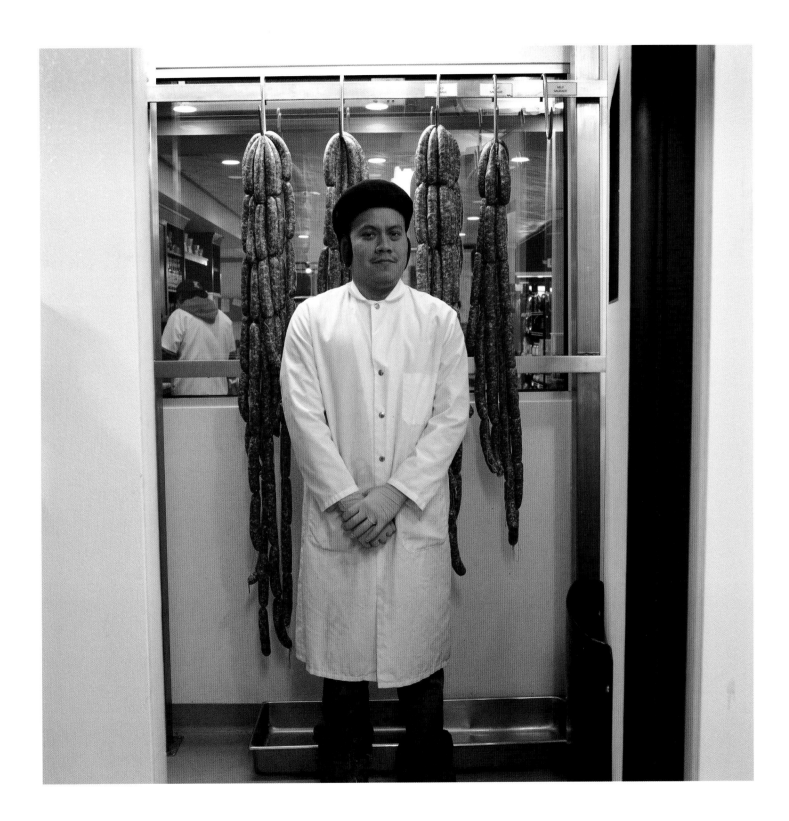

Yellowstone Implement, Stanley
Established 1917 by Armand
Christopherson, purchased 1951
by Ryland Shock

Jim Shock ran his dad's farm equipment
business with his brother Walter until
Walter's retirement a few years ago.

#4566

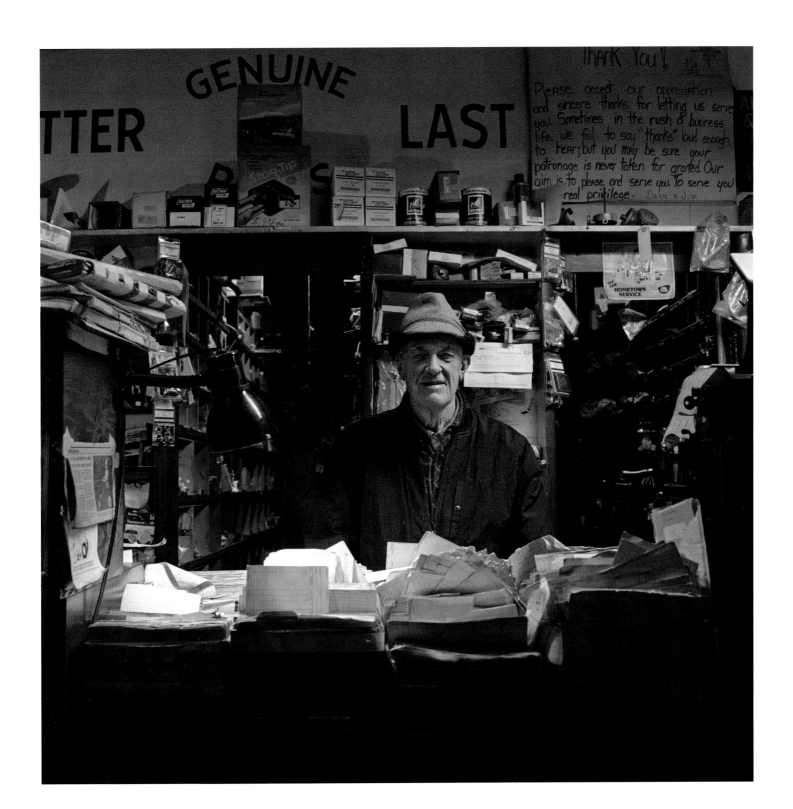

Kaber's Supper Club, Prairie Du Chien
Established 1920 by Henry and
Emma Kaber

Kaber's began as Kaber's Café; it was
called Kaber's Nite Club in the '30s
and '40s, when it featured live music
and dancing. Owner and chef Jon
Kaber says he is most proud of his
grandmother's chilled beet recipe.

#3567 | #3565

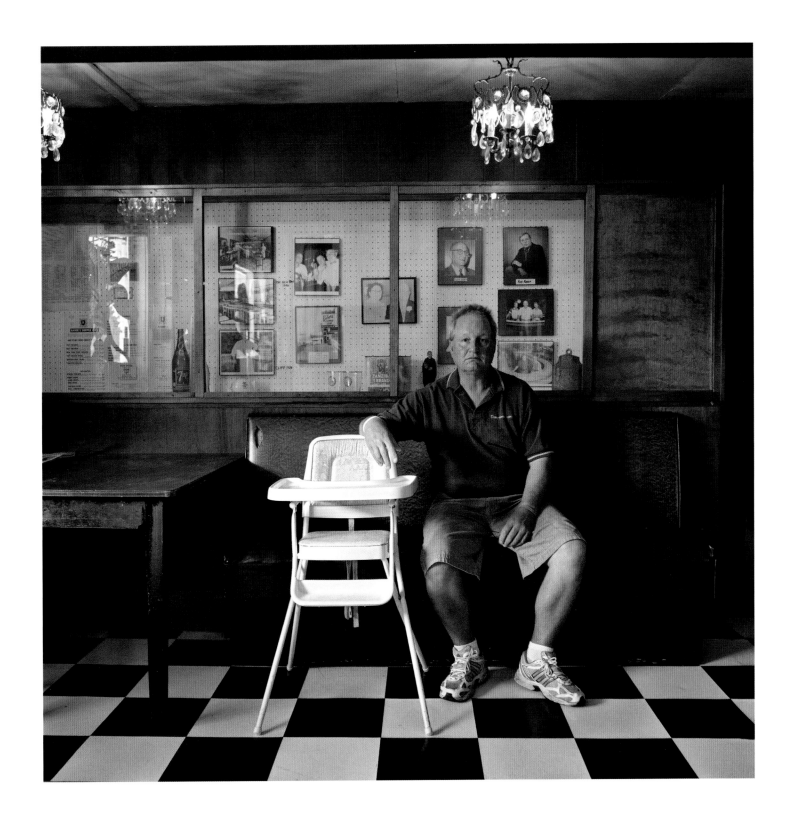

Dick Bjerstedt's Garage, River Falls
Established 1961 by Dick Bjerstedt

Dick Bjerstedt has a sign in his garage
that reads, "If there are no dogs in
heaven, then when I die I want to go
where they went." Dick is one of my
favorite people. You can't get out of
there in under thirty minutes, and you
don't want to.

#3332 | #3333

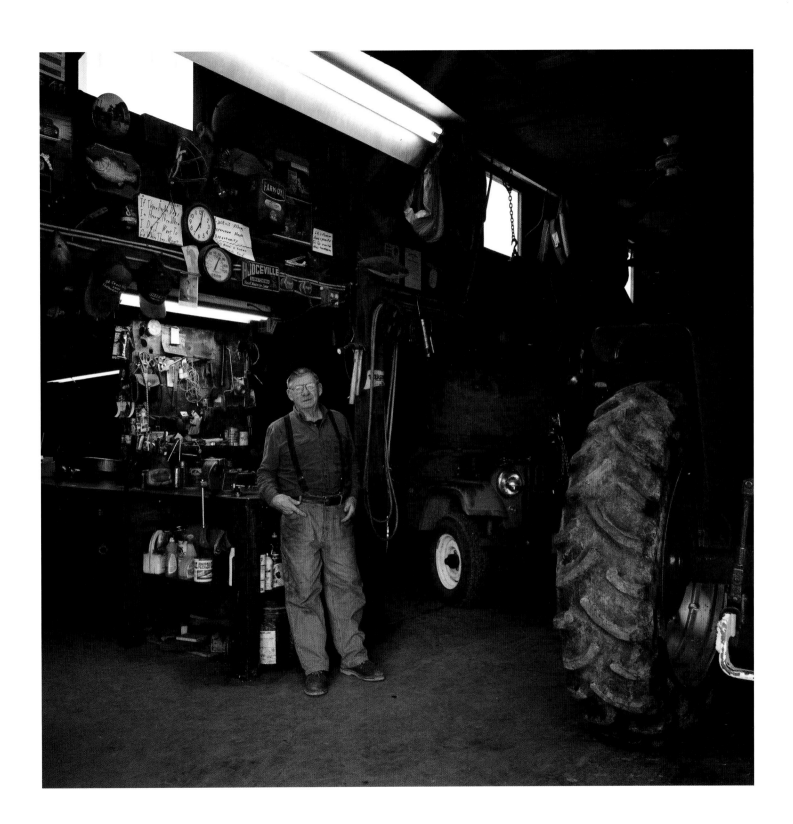

**Globe House Furnishing, Marinette
Established 1888 by Tobias Kirmse**

I made these pictures two weeks after
the store's liquidation auction in 2010.
Mary McCarrier, here holding a portrait of
her grandfather Tobias Kirmse, told me
that Globe could no longer compete with
the big-box stores. She said the family
was doing fine; her main concern was for
her vendors, who are losing business as
small independent retailers disappear.

#3119 | #3108

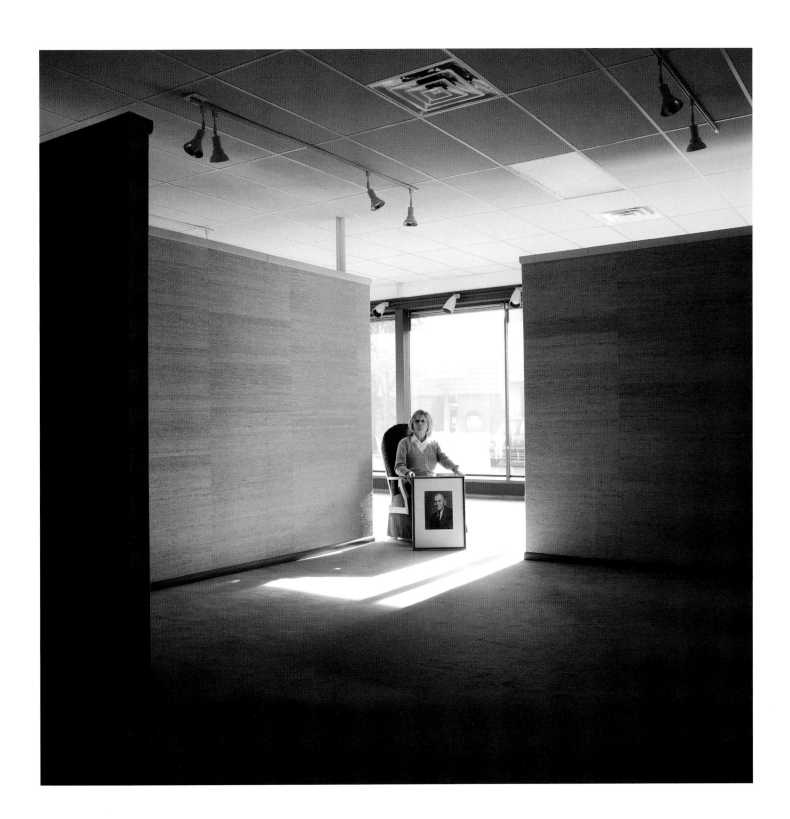

Mondovi Hardware, Mondovi
Established 1905 by Edward Erickson

Five generations of the Erickson family
have run Mondovi Hardware.

#3976

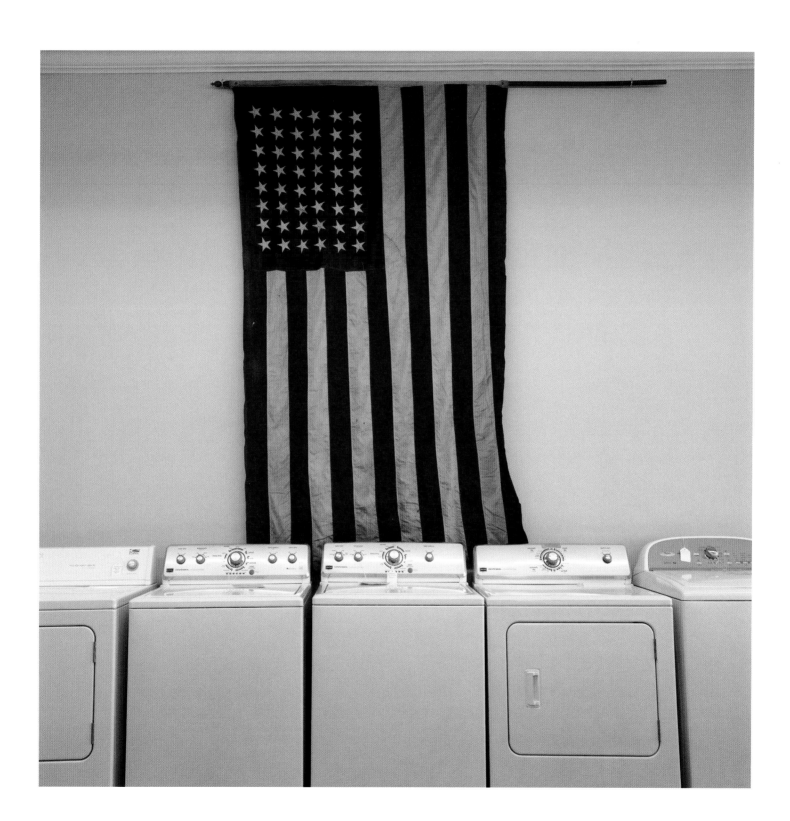

INDEX